STANLEY SPENCER

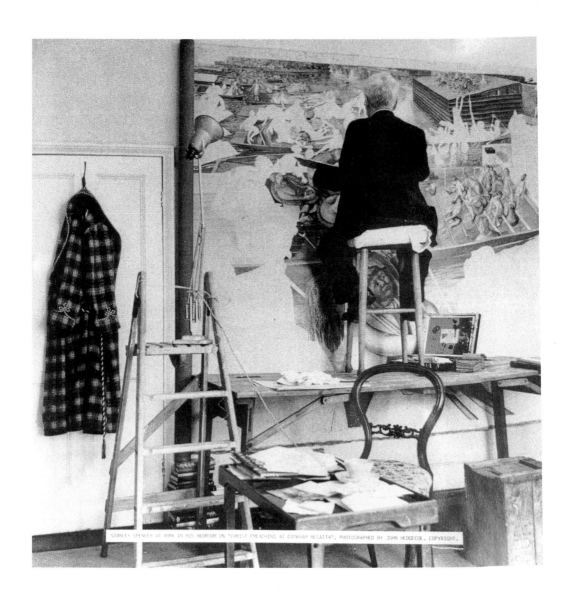

STANLEY SPENCER

Kitty Hauser

British Artists

Princeton University Press

Front cover: *St Francis and the Birds* 1935 (fig.14)

Back cover: *Christ Carrying the Cross* 1920
(fig.29, detail)

Frontispiece: Photograph of Spencer at work in his
bedroom on *Christ Preaching at the Cookham Regatta*
by John Hedgecoe

Published by order of the Tate Trustees by
Tate Publishing, a division of Tate Enterprises Ltd,
Millbank, London SW1P 4RG

Published in North America by
Princeton University Press
41 William Street
Princeton, New Jersey 08540
www.pup.princeton.edu

© Tate Publishing 2001

The moral rights of the author have been asserted

ISBN 0-691-09024-6

Library of Congress Control Number: 2001087269

Cover design Slatter-Anderson, London

Concept design James Shurmer
Book design Caroline Johnston

Printed in Belgium by Snoeck-Ducaju & Zoon

Measurements are given in centimetres, height
before width, followed by inches in brackets

CONTENTS

Acknowledgements 6

Introduction 7

1 Home 15

2 Cookham 30

3 Love, Sex and Marriage 46

4 Chapels of War and Peace 61

Chronology 77

Notes 77

Select Bibliography 79

Index 79

ACKNOWLEDGEMENTS

For their generous help of different kinds I'd like to thank Nicola Bion; Felitsa, Ben and Ariadne Birnberg; Michael Dickens; David Fraser Jenkins; Jane Garnett and Gervase Rosser; Adrian Glew and the staff of Tate Archive; Richard Humphreys; Richard Hurley at the Stanley Spencer Gallery; Tim Hyman; Katherine Rose; Unity and Shirin Spencer; Julian Stallabrass; Carl Thompson; Gemma Wright; and – especially – my mother and my father.

INTRODUCTION

Stanley Spencer (1891–1959) is one of the best-known and best-loved of all twentieth-century British artists. He is famous for two things: his immortalization of his home village of Cookham, in a series of often astoundingly beautiful images; and his celebration of sex both in his painted works and in his unconventional attitude to relationships. 'Remote things join in me,'[1] wrote Spencer, whose aim as a mature artist was to fuse together in his work things that are everywhere separated: the sacred and the profane, religion and sex, the real and the imaginary, love and dirt, public and private, the young and the old, the self and others, the heavenly and the earthbound.

Those who met Spencer were frequently startled by his unkempt and boyish appearance, and his extraordinary flow of talk, moving seamlessly between biblical references, his domestic affairs, childhood memories, views on marriage, sexual freedom and painting. For fifty years this so-called 'village boy' produced some of the strangest and most haunting images in British art. In the painted world he created, families emerge from their cosy graves in a Cookham cemetery and float off down the river Thames on a pleasure-boat; Christ in a straw boater preaches to the crowds at Cookham Regatta; St Francis appears in a green dressing-gown in a back garden; a sunflower and a woman make love; and the artist's second wife is depicted naked alongside a leg of mutton.

Most of these images depict places and people taken from Spencer's own life, places and people that he loved. Spencer's ideas, and the paintings that arose from those ideas, were intimately connected to the events in his life and the relationships that he had with others. Those relationships, particularly the scandal associated with his second marriage, have made him as renowned for his private life as for his art. There is a danger, in discussing Spencer, that a serious consideration of his paintings might be eclipsed by a fascination with his personality, and the soap opera that was his love life. But even if it were possible to discuss Spencer's paintings without referring to his personal life, it would be a serious misrepresentation of the work. Spencer became a painter not in order to make *art* as such, but in order to express the excitement and the feelings that he had about places and people. Just about everything that happened to him – every experience he had, every place he spent time in, every house he lived in, and every person he met, knew or loved – found its way into his writing, and into his art. Here everything was recycled, reworked, and – he hoped – *redeemed* in paint.

Spencer is often described as a visionary artist, who like other visionaries experienced a powerful and transcendent sense of absorption in the world. Spencer himself was very loquacious, especially in later life, on the subject of his childhood vision, inseparable from his home village. Wandering in the marsh meadows, bathing in the pool at Odney, or strolling across Widbrook

Common, the young Spencer was filled with joy and a feeling of oneness with the world around him. The feelings Spencer had for Cookham were, he said, religious in their intensity. Initiated into the rites of marriage, Stanley enthusiastically adapted his vision to include the new territory of sexuality. But throughout his adult life Spencer worried obsessively that he had become estranged from his Cookham vision, believing it to be the wellspring of his creativity. Experience (especially sexual experience) had replaced innocence, and Spencer struggled – often heroically – to reconcile his adult world with the lost but authentic vision of childhood.

Spencer's unique vision has become part of the Spencer mythology. His biographers have been by turns enchanted or perplexed by the artist's own descriptions of it, which were often eloquent, but sometimes obscure and repetitive. Secondary literature on Spencer does not always illuminate his unorthodox eye. What, exactly, Spencer's vision consists of in itself may be best left to the artist himself to explain in his own words and works. But whatever it was, Spencer's vision was far from being a transcendent phenomenon, floating free from its historical, social and geographical co-ordinates. Revelling in the ordinariness of the world around him, Spencer's brand of mysticism was firmly grounded in material reality. It was a vision mapped onto a network of particular places in all their topographical, social and architectural complexity. His vision is also inextricable from the people he knew, those he met and especially those he formed relationships with. The paintings he left us with are the repository of his feelings about places, things, books, pictures, houses and people, all of which had a historical reality before they became part of his imagination, and the building blocks of his art. This book will try to see how Spencer's work grew out of places, experiences and social relations that were both real and subsumed into his imagination, where they were transformed into paintings.

1 *The Resurrection, Cookham* 1924–7
Oil on canvas
274.3 × 548.6
(108 × 216)
Tate

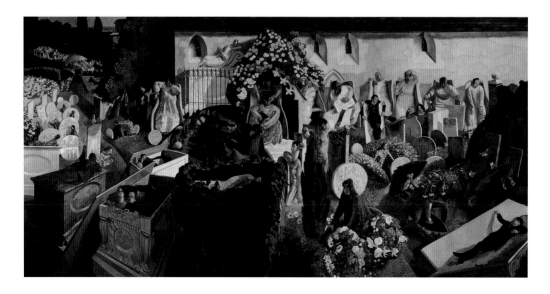

Spencer's critical heritage

Spencer first found fame and critical acclaim in 1927, when his painting *The Resurrection, Cookham* was exhibited in a one-man show at the Goupil Gallery in London (fig.1). The painting was bought for £1,000 by the Duveen Paintings Trust, and given to the Tate Gallery. Together with his subsequent work at the Sandham Memorial Chapel at Burghclere, *The Resurrection, Cookham* established Spencer's reputation as a painter, and in 1932 he was elected to the Royal Academy. In the later 1930s, as he became preoccupied with sex both in his art and in his personal affairs, there was a marked shift in both the style and the content of Spencer's paintings. In 1935 two of his paintings were rejected from the Royal Academy, which led to the artist's resignation, in disgust, from an institution that – he felt – did not understand his art. But it was not just the Royal Academy that was challenged by Spencer's work in the 1930s. Contemporary critics who saw his so-called 'sex pictures', with their distorted figures and curious juxtapositions, found it hard to see any merit in them. At times, Spencer himself lost confidence. In an introduction to his Tate retrospective exhibition in 1955, he voiced his fear that none of his later work ever matched his early paintings of Cookham.

However, Spencer never gave up on his great task of fusing together the themes of religion and sexual desire. Right up to the end of his life he was planning increasingly elaborate schemes in which all of his figure paintings would become part of a sequence that would bring together all his desires, needs and loves, housed in a purpose-built structure he thought of as his 'Church-House'. The Church-House was never realised, however, due to the lack of a patron. Spencer despaired of the fact that the paintings that meant so much to him consistently failed to find buyers. Throughout his life he supplemented his income with landscapes, for which there was always a demand. Spencer's landscape paintings – like his portraits – are strikingly skilful, particularly in their almost hallucinatory attention to detail, but he resented painting them, since they distracted him from the work in which he had invested so much of his imaginative energy. Neither did he rate them as highly as the art-buying public evidently did. 'I do my landscapes with a great deal of application and care,' he wrote, 'but they are dead, dead.'[2]

Reinstated at the Royal Academy in 1950, and knighted in the summer of 1959, Spencer died a renowned artist. Since his death, his critical reputation has fluctuated according to the broader fortunes of figurative painting and narrative art. Until the 1970s, at least, his wilful parochialism meant that writers could only accommodate him into an art history dominated by modernism by aligning him with a lineage of visionary 'outsiders' in British art, notably William Blake. Spencer, after all, had deliberately distanced himself from the modern movement. While at the Slade School of Art, like his fellow-students he was certainly affected by the developments in modern painting in France; the simplified forms and bold use of colour of his early work have something in common with Gauguin in particular. But Spencer's insistence on the importance of subject-matter separated him from those modernist painters who were his contemporaries in London and Paris.

Modernist painting concerned itself primarily with formal values, banishing narrative content, whereas Spencer insisted that form followed subject matter in his work. 'Knowing *what* to paint,' he wrote, 'gives me the appetite for painting.'[3] The places and people depicted in Spencer's art were never merely the excuse for a painted exercise in colour, form and composition, as they might be in a strictly modernist work. Like Victorian narrative paintings, Spencer's images were meant to be read, and like the early Italian Renaissance art he so admired, they aimed to serve a higher purpose than art for art's sake. Spencer's paintings were conceived almost as votive offerings to their subject-matter – 'a way of saying "ta" to God', as he often put it – an attitude to painting that sits rather uncomfortably alongside the work of Picasso, Jackson Pollock or Francis Bacon.

As modernist genealogies began to be questioned in the 1970s and 1980s, a general rewriting of art history had the effect of re-evaluating those artists whose work had never quite conformed. At the same time, a resurgence of figurative painting amongst contemporary artists renewed interest in painters such as Spencer, who had successfully fused modernist form with narrative content. Since the late 1970s, Spencer's paintings have not only been the subject of a series of major exhibitions in Britain, they have also been 'discovered' in Europe and America, sealing his international reputation, and pushing up prices for his work at auction. Spencer could now be repositioned by art historians in a rich seam of artists from around the world, including Max Beckmann, Otto Dix and other *Neue Sachlichkeit* artists, Diego Rivera, Balthus and Marc Chagall, artists whose differences – not least their political differences – are surely as significant as their similarities. Spencer may have been reclassified; but arguably he remains as much of a stranger in this eclectic company.

Despite these fluctuations in the critical appraisal of Spencer, he has long been popular in his home country. Almost uniquely amongst twentieth-century British painters, Spencer inspires the enthusiasm of those who otherwise might be uninterested in modern art, at the same time as he has won the respect of a number of professional critics and practising painters. It is worth considering some of the reasons why Spencer might enjoy this broad popularity, bearing in mind that his work is disliked in some quarters for exactly the same reasons that it is admired in others.

In part, Spencer's popularity must be due to the undoubted sincerity of his vision, the mysterious beauty of his imagery, and his celebration of life-affirming themes such as home, nature and conjugal and familial love. Spencer only wanted to paint those things that he loved, and his work comes as a balm to those who are appalled by the horrors of modern life, and disappointed by art's apparent inability to rise above them. Spencer's art is defiantly affirmative, in a world that seems to have deemed such optimism unsustainable. In an age of dizzying globalisation, too, Spencer's intimate relationship with a particular place holds a powerful attraction for those who are alarmed by the speed at which individuals and communities are uprooted, exiled and dispersed. 'Homelessness,' wrote Martin Heidegger in 1947, reflecting on the modern condition, 'is coming to be the destiny of the world.'[4] It is often hard to say where, exactly, 'home' is, when we have moved from town to town, or

country to country, and our families are scattered across the globe. Home is something many of us seem to have lost, something we yearn for. Seen in this context, Spencer's comfortable connection with Cookham acquires a particular attraction for modern audiences.

Spencer has sometimes been seen as a quintessentially English artist. This is due, no doubt, to his unapologetic celebration of parochial life in a small community unscathed by industrialisation, a vision that happens to coincide with a long-standing idea of Englishness that is identified with idyllic villages in the Home Counties. This is an idea that sees the local as the very essence of the national. Yet Spencer himself does not seem to have seen himself or his work as specifically English. Many of his most extraordinary images depict scenes in the Balkans, Switzerland or Glasgow. And while he may have valued certain qualities associated with Englishness, it was Cookham Spencer loved, not England as such. When he was posted to Macedonia on active service in the First World War, it was Cookham, not his country, that he missed. Neither did Cookham stand for England in Spencer's mind, as the Cambridgeshire village of Grantchester did, for example, for the poet Rupert Brooke. But for as long as there is a tendency to equate Englishness with the provincial, the homely and the socially harmonious, Spencer's paintings of Berkshire – particularly his landscapes – will continue to charm those who are nostalgic for a dreamtime England of cosy cottages, walled gardens and blooming horse-chestnut trees, a vision in which Spencer himself – ironically – had little interest.

Furthermore, whilst in its broad brushstrokes, bold compositions and flattened surfaces Spencer's work is recognisably modern, its subject matter reassuringly delves deep into the familiar narratives, landscapes and figures without which modernist art remains cold and incomprehensible to many viewers. As one critic noted approvingly, speaking of *The Resurrection, Cookham* in 1927 in *The Times*, 'What makes it so astonishing is the combination in it of careful detail with modern freedom in the treatment of form. It is as if a Pre-Raphaelite had shaken hands with a cubist.'[5] It is surely this cosy *rapprochement* between modern forms and narrative painting, refusing the alienating rupture of modernist art, that – as much as anything else – might account for Spencer's appeal.

Spencer's writings

Finally, a word on sources. In addition to his paintings and drawings, Spencer produced a vast quantity of written texts. When he died, he left several trunks full of notebooks, diaries, letters, lists and miscellaneous autobiographical writings. Spencer was fascinated by himself, and obsessively scrutinised his desires, memories, works and thoughts in his writing. The physical act and emotional release of writing played an important part in Spencer's life, particularly in the lonely period following the break-up of his marriages, when he often wrote nearly every day. A large proportion of his writings took the form of letters to his first wife Hilda, a correspondence that continued even after her death in 1950, and that he documented in *Love Letters*, a painting from the

same year (fig.2). Some of these letters were sent, but many he kept, since he intended that they should form the basis of an autobiography that he had been working on since the late 1930s. Spencer's autobiography was an open-ended project in which nothing of himself, he thought, should be left out: no thought, no memory, no feeling should go unrecorded. The structure of this planned autobiography – such as it was – had little respect for chronology, but veered from subject to subject, episode to episode according to his own whims and thought-associations. This work – by definition – was unfinishable and deemed unpublishable, and it remains along with his other writings in the Tate Archive.

A sizeable proportion of Spencer's writing consists of lengthy analyses, lists and descriptions of his paintings, often included in letters to Hilda. Perhaps more than any other artist, he expended almost as much energy in describing his paintings as he did in creating them. Even after his works had been made, exhibited and sold, Spencer would return again and again to them in his writings, analysing their hidden meanings, and their place in his oeuvre as a whole. The paintings that we see are just the visible tip of a whole iceberg of meaning ascribed to them by their creator. Every gesture has significance, every place is connected to a world of associations in Spencer's mind. These esoteric and personal meanings are far from self-evident from the images alone, leaving the critic unavoidably in the dark. Unsurprisingly, Spencer rarely approved of criticism of his work by others, maintaining – with some

2 *Love Letters* 1950
Oil on canvas
86.5 × 117 (34 × 46)
Thyssen-Bornemisza
Collection, Lugano

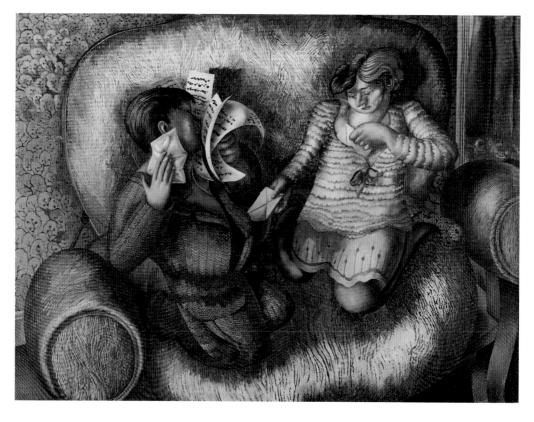

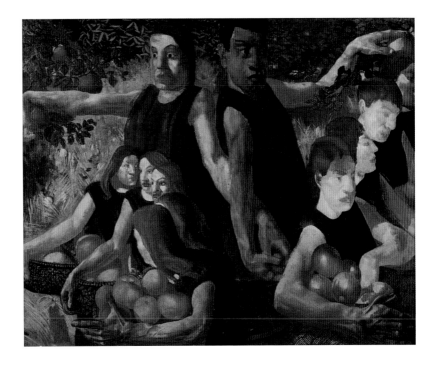

3 *Apple Gatherers*
1912–13
Oil on canvas
71.4 × 92.4
(28⅛ × 36⅜)
Tate; Presented by
Sir Edward Marsh
1946

justification – that he was the only person who really knew what his pictures were about.

Spencer's commentaries on his paintings therefore offer us a key to the hidden world of meaning that is such a crucial component of his work. Spencer called himself the 'hierophant' of his art, the high priest of the esoteric mysteries of his own devising.[6] This is so self-evidently true it is almost tautological – only the founder of a personal mythology can explain its rites, its protagonists and its legends. But this does not mean that Spencer's paintings need to be appreciated or understood *solely* according to his own interpretations, enlightening though they are. For a start, these paintings are not designed to be accompanied by explanatory texts. And in any case, Spencer's analyses of his own pictures are far from consistent. His interpretation of *Apple Gatherers*, for example, altered considerably between the time when he painted it, and when he reflected on it later in relation to the awakening of his own inchoate sexuality (fig.3).

Writing about his paintings was for Spencer partly a way of writing about himself. As events in his life threatened to disturb his sense of self, he revisited his old works in an attempt to re-thread all his paintings and experiences onto a continuous line of evolutionary development that reassured him of his unique and consistent vision. At different times he felt the need to stress different aspects of that vision. Spencer's retrospective writings about his works need to be themselves historicised and contextualised, for they are often part of the artist's active attempt to revisit lost places, relive past experiences, and corral the disparate aspects of his life and work into a total autobiographical scheme. Spencer rarely forgot his paintings, even after they had been sold. He

lived with them all, in memory if not in fact; and they were often the *starting-point* of later fantasies as well as the reflection of particular 'notions' at the time they were created.

Sifting through Spencer's writings, one gets the impression of a man who was physically, spiritually and intellectually excited by his responses to the world, and who felt an unusually strong desire to express that excitement in paint and in words. The world, however, did not always please Spencer, or bend to his wishes, and in his art he sought to create a painted world that was not subject to the same laws as the real one. Here everything and everyone was redeemed; here he could create a home when his own was threatened; he could possess the women he loved when they had refused him; he could transfigure ordinary objects into the heavenly attributes of those who are newly reborn in a state of beatific and orgasmic joy. Art, for Spencer, was the necessary crucible in which he could transmute lived reality into a reality he could live with. In order to understand how he did this, we need to pay equal attention to Spencer's works and words, and the material world out of which they came.

1
HOME

Stanley Spencer was born on 30 June 1891 in the Berkshire village of Cookham-on-Thames, the second youngest of the nine surviving children of William and Anna Spencer. Both Spencer's parents had been brought up locally. His mother's family, the Slacks, had run a grocer's shop, whilst his father's father, Julius Spencer, was a master builder who ran the village choir. Spencer's grandfather built a number of buildings in Cookham, including a pair of semi-detached villas named 'Belmont' and 'Fernlea', intended for his two sons. Spencer and his brothers and sisters grew up in Fernlea, whilst his uncle, Julius Spencer, raised a family in next-door Belmont (fig.4). These houses, according to Spencer's brother Gilbert, 'were very ugly, with their yellow bricks, cast-iron railings and slate tiles. And yet we grew to love them like no other place on earth.'[1]

William Spencer initially followed his father into the building trade, but he earned a living through teaching and playing music. Spencer's father (or 'Pa', as he always called him) was the organist and choirmaster at Hedsor church, near Cookham. At Fernlea, he attached a sign reading 'Professor of Music' to the gate, and took in paying pupils for lessons in piano playing and singing. Music played a large part in Spencer's early home life as a result of his father's profession. Listening to music, wrote Gilbert, was 'as much a part of our lives as breathing'.[2] But William Spencer was not only a musical enthusiast; he was a Victorian polymath who dabbled excitedly in astronomy, theology and poetry-writing. Creative and intellectual activities of all kinds were an everyday component of family life in Fernlea. While 'Pa' read the works of Ruskin, or played a Bach fugue on the piano, Spencer's elder brother Horace tried out his conjuring tricks, his sister Annie practised the viola and Gilbert (who later became an artist) made miniature model farms at the kitchen table (fig.5).

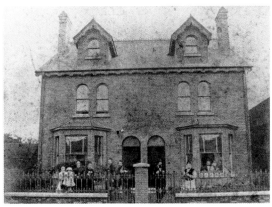

4 Photograph of Fernlea (right) and Belmont (left), c.1880 Spencer's parents are standing in the front garden of Fernlea Estate of Stanley Spencer

15

In this cramped but creative home environment, Spencer's painting and reading of the classics did not seem anything particularly out of the ordinary, although it was sometimes hard for him to find a corner in which to work. 'Pa', who was an unusual combination of trained craftsman, patriarch and self-taught intellectual, helped to create a home environment within which it was normal to perform, write, or discuss abstract ideas with passion. In Spencer's family there was none of the philistinism or anti-intellectualism often associated with the middle classes of that period. Visual art, as such, did not play a large part in the Spencer household. But creative pursuits in general were happily accommodated, despite lack of space. And the fact that Spencer came from a home where artistic ambitions were part of the warp and weft of domesticity meant that his art and the idea of home could remain comfortably entwined in his imagination.

Religion was also an important part of this warp and weft of domestic life at Fernlea. Reading, out loud, from the family Bible was an integral part of daily life in the Spencer household. William Spencer regularly expounded biblical parables and homilies to his children, and in their nursery the young Stanley and Gilbert read sections of the Bible in accordance with a 'card-index system of dates and portions to be read'.[3] Like most middle-class Victorian families, the Spencers were regular church-goers. While William Spencer was Church of England, his wife was a Methodist, and so Spencer went to both the village church and the Wesleyan chapel (now the Stanley Spencer Gallery). According to Spencer, 'the religious factor was the most family part of our life. I do not mean that there was any insistence on the point. I mean it was the abiding part of the family atmosphere.'[4] Through Bible reading at home, and services at Church and Chapel, Spencer was thoroughly immersed in the Christian faith and Christian stories. These stories, and the places in which he heard them told, would later find their place in paintings such as *The Nativity*, *Zacharias and Elizabeth* and *The Marriage at Cana*.

Spencer's parents, it seems, did not entirely approve of the schooling provided under the 1870 Education Act, and so William Spencer began his own school in the garden of 'The Nest', the next-door cottage. At another point he opened a 'Free Library' in the sitting room at Fernlea. Neither project flourished (the books in the library were too high-minded); but the school begun by 'Pa' was eventually taken over by Spencer's sisters, Annie and Florence, and it was in this cosy establishment that Spencer and his brother Gilbert received their formal education, such as it was. Spencer's limited education was a source of some embarrassment to him later on, but also a source of pride. The environment within which he grew up was a potent combination: it was culturally rich, without being academic; it encouraged a degree of free thinking, within a patriarchal and church-going family; it valued self-improvement and individual spiritual seeking, while familial bonds remained strong. Culture and religion were comfortable in the Spencer household, as much a part of domestic arrangements as the coal-scuttle, the kitchen-range or the nursery beds. It was in this environment that Spencer became an artist.

With few lessons to attend, and with no particular goal in mind, the young Spencer started to copy illustrations in the books that he found around him,

5 Photograph of Spencer family (from left to right): Gilbert, 'Ma' Spencer, Annie, Stanley, Will (behind), Florence, Percy (in the tree), Horace, 'Pa' Spencer, Sydney and Harold, c.1895
Estate of Stanley Spencer

which included the family Bible, natural history books, and E.H. Stead's 'Books for the Bairns' series, including *Pilgrim's Progress*, *Don Quixote*, and the Brer Rabbit stories, illustrated by Brinsley Le Fanu and others. From here, Spencer expressed a desire to draw like the children's book illustrator Arthur Rackham, and he began to draw scenes around Cookham, as well as some imagined scenes with biblical and mythological subjects, all in pen and ink. By the time he reached his mid-teens, Spencer thought he wanted to be an artist. His father, who was unsure how best to proceed, sent him and Gilbert to a local artist, Dorothy Bailey, to be taught watercolour painting. In 1907, Spencer enrolled for classes at the Technical Institute in the nearby town of Maidenhead, where he spent his time drawing from plaster casts. Then in 1907, at the age of 16, he began at the Slade School of Fine Art in London, initially sponsored by Lady Boston, one of the patrons cultivated by his father to support the talents of the Spencer family. Spencer did not move to London, however. For the next four years, every day during term-time, he would take the 8.50 train from Cookham to Paddington, and the 5.08 train back again to arrive home in time for tea.

The years of Spencer's training at the Slade coincided with the culmination of a period of extraordinary artistic experimentation in Europe that would alter the course of Western art. Cézanne's studies of form and light in Aix-en-Provence, Gauguin's luminous images of Brittany and Tahiti, and the bold and colourful pictures of Van Gogh, with their emphasis on light, pure form and the emotional power of colour, had revolutionised painting by the turn of the century. While the teenaged Spencer was commuting to and fro between London and rural Berkshire, in their Paris studios Picasso and Braque were inventing a new approach to painting that broke completely with the traditional goal of illusionistic representation. British audiences were made aware of developments on the Continent largely through the efforts of critics Clive Bell and Roger Fry, who put on two influential exhibitions of Post-Impressionist painting in London in 1910 and 1912.

In the period before the First World War, the Slade was the pre-eminent art

school in Britain for young painters with a taste for Bohemia. A list of Spencer's fellow students reads like a roll call of British modernists of the period: Edward Wadsworth, Paul Nash, Dora Carrington, C.R.W. Nevinson, David Bomberg, Mark Gertler. But if Post-Impressionism was influential amongst the Slade students, so too was the lingering appeal of the Pre-Raphaelites, with their detailed storytelling, truth to nature and magical poeticism, and the work of early Italian painters such as Giotto and Fra Angelico, with their pure colours, starchy gestures and mystical atmospheres. Seen through the modernist eyes of Fry and Bell, these Italian 'Primitive' painters exhibited formal qualities comparable with Cézanne. Unlike Fry and Bell, however, Spencer was convinced that a painting – like the illustrations in his childhood books – should have both subject and purpose, and he was entranced by the atmosphere of these paintings as much as their compositional value.

The influence of Victorian art is evident in the work produced by Spencer during his time at the Slade. Drawings like *The Fairy on the Waterlily Leaf* (*c.*1909) (fig.6) and *Jacob and Esau* (1910–11) are reminiscent of the graphic works of Pre-Raphaelite painter John Everett Millais, while still retaining the abiding influence of Arthur Rackham and Le Fanu. Like Pre-Raphaelite images, and like children's book illustrations, these scenes seem to take place in a faintly archaic parallel universe, where a narrative is indicated – somewhat obscurely – by the gestures and props of storybook characters. Yet in Spencer's drawings the depicted universe is not quite separate from the real

6 *The Fairy on the Waterlily Leaf c.*1909
Pen and ink on paper
41.5 × 32
(16¼ × 12½)
Stanley Spencer Gallery, Cookham

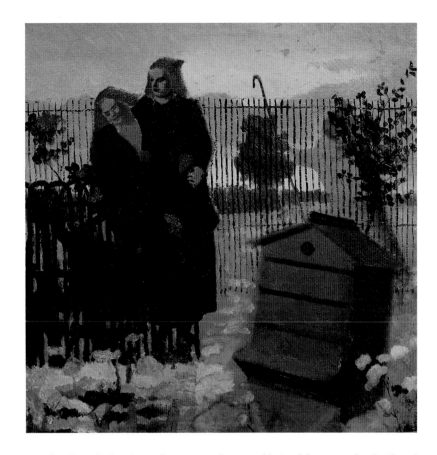

*7 Two Girls and a
Beehive c.1910
Oil on canvas
48 × 48 (19 × 19)
Collection: Lord and
Lady Irvine*

one that he inhabited. In *The Fairy on the Waterlily Leaf*, for example, the 'fairy' was a portrait of his childhood friend Dorothy Wooster (who also appears with her sister in one of Stanley's first paintings, *Two Girls and a Beehive* (c.1910) (fig.7), and the scene in which she appears takes place on the banks of the river Thames at Cookham. Although he barely knew it at the time, it was personal and homely elements such as these that would become Spencer's artistic *leitmotif*.

During the time of Spencer's attendance there, teaching at the Slade emphasised precise and disciplined drawing, under the strict guidance of Henry Tonks. Spencer spent practically all his time at the Slade drawing either from antique statues or from life models, and he soon became a skilful draughtsman. Close observation, accurate drawing and disciplined composition would form a crucial part of his working practice for the rest of his life, giving him the essential tools with which to make manifest his ideas. The draughtsmanship Spencer acquired in the Slade life-drawing room is evident in his early imaginative works, including *The Fairy on the Waterlily Leaf, Jacob and Esau* and *Scene in Paradise*, most of which were produced in response to specific subjects set by the Slade Sketch Club. It was in these images that Spencer first fused together the biblical themes that were so familiar to him with equally familiar elements from his childhood home. The homely element in *Scene in Paradise* (fig.8), for example, is a clothes-horse that Spencer remem-

8 *Scene in Paradise*
1910
Pen and ink and
brown wash 34 × 40
(13⅜ × 15¾)
College Art
Collections,
University College
London

bered 'standing round the kitchen fire' at Fernlea, where it made a 'sort of house'.[5] Spencer later saw it as significant in this picture 'that I have tried to bring the three experiences of my life together, quite unconsciously, namely the Slade with the life drawing (the nude is just a model), the life at home, and the feeling the Bible gave me'.[6]

During his years at the Slade, Spencer taught himself to paint in the evenings, at weekends and in the holidays. If Pre-Raphaelitism, Arthur Rackham and careful visual description still suffused his drawings, his first paintings – in format and technique, if not subject matter – seem to exhibit certain traits characteristic of modernist art. In 1911, in the bedroom he shared with his brother Gilbert, Spencer completed a painting entitled *John Donne Arriving in Heaven* (fig.9). The bold blocks of colour and simplified figures in this picture led Tonks to accuse him of having been influenced by the first Post-Impressionist exhibition in 1910. Spencer seemed not to be pleased by the inference; yet he agreed to allow this painting to be included in the second Post-Impressionist exhibition in 1912, where it hung alongside the work of Matisse, Picasso, Wyndham Lewis and Vlaminck. His next painting, *The Nativity* (1912), won first prize for composition in the Slade summer painting competition (fig.10). The religious simplicity of this biblical scene recalls the work of early Renaissance artists like Piero della Francesca. Again, the scene is placed in a local setting, and the simplified figures, with their crude features and static gestures, owe something to the paintings of Gauguin, whose influence is felt even more strongly in Spencer's next painting, *Apple Gatherers* (1912–13), which according to him was his 'first ambitious work' (fig.3).[7]

In these works, Spencer was attempting to represent specific places in such a way as to bring out the meaning he perceived to reside in them. This meaning was not the same as the objective visual appearance of a place, and so pure landscape painting would not do. It was the *feeling* that a particular place aroused in him, the physical and emotional effect that it had on him, that he wanted to depict in paint. The 19-year-old Spencer was just becoming aware of 'the rich religious significance of the place I lived in. My feeling for things being holy was very strong at this time.'[8] Spencer's early paintings are his first attempts to find a formal means of expressing these feelings. 'The marsh meadows,' he wrote in 1935, 'leave me with an aching longing, and in my art that longing was among the first I sought to satisfy.'[9] But how could this longing be satisfied in paint?

Spencer sensed that the straightforward depiction of a particular place would not capture its special atmosphere. Pure landscapes, painted *en plein air*, made him feel 'lonely'.[10] The way forward, it seemed, was to explore the relationship between figures and places, in works of the imagination and

9 *John Donne
Arriving in Heaven*
1911
Oil on canvas
37 × 40.5
(14½ × 16)
Private collection

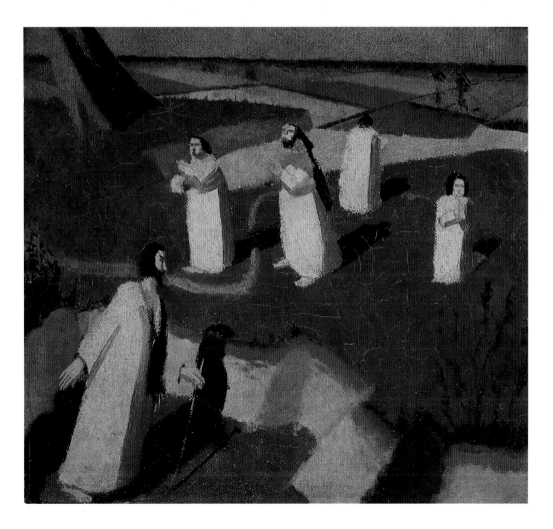

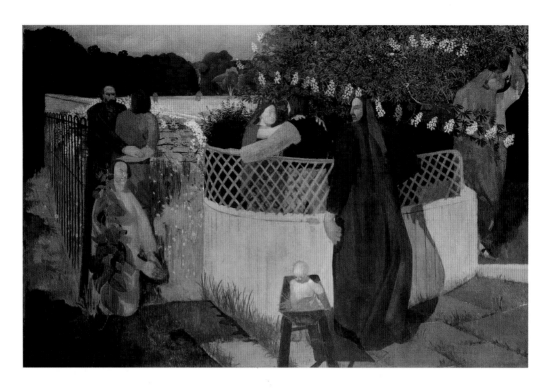

10 *The Nativity* 1912
Oil on canvas stuck
to board
102.9 × 152.4
(40½ × 60)
College Art
Collections,
University College
London

memory. 'It was when I painted what I had imagined,' he wrote, 'that I came nearer the feeling that Cookham had for me.'[11] A meaningful human presence, deliberately placed in a familiar location, could enchant both figures and setting, suggesting a felt occult significance. A landscape painting of Widbrook Common might not convey the special feelings that Spencer had about it. But by incorporating the Common as Heaven in a narrative picture, as he did in *John Donne Arriving in Heaven*, this otherwise mundane location is transformed into an otherworldly realm through the presence of the figures. *Apple Gatherers* similarly incorporates real places in an imagined scene designed to convey the unique identity of a specific location, in this case the orchard beyond Fernlea garden as seen from the nursery. Spencer developed the idea that the inhabitants of a particular place were the living embodiments of that place. 'A person is a place's fulfillment,' he wrote, 'as a place is a person's.'[12] Something of this mystical interconnection between person and place lies behind *Apple Gatherers*. The figures, according to Spencer, are not simply apple-pickers, but represent 'the natural outcome of the place'. Through these figures 'the apples and the laurel and the grass can all fulfill themselves'.[13] And how much nicer than working outside on a landscape it was to work 'with par at my back just by my elbow and he playing his Joachim Raff, or giving a piano lesson to one of a row of children these last sitting against the far wall and waiting their turn'.[14]

As a result of his Slade training, together with his exposure both to the Old Masters and Post-Impressionist painting, Spencer knew how to construct a picture that was pleasing to the modernist eye. A pleasing composition was never enough, however. He was beginning to realise that in order for him to

enjoy a drawing or a painting, in order for it to be a meaningful activity, it had to contain something that meant something to him – inevitably something from home. In 1915, Spencer painted the oasthouses that were visible from the nursery window of Fernlea. *Mending Cowls, Cookham* (1915) is an extraordinary painting whose stark and well-constructed composition, with its solid blocks of form and colour, align it with modernist painting. (fig.11) This is an image that could be interpreted in purely formal terms; it certainly does not seem to tell a story or point a moral. Yet to the artist it was a picture brimming with meaning. Writing to his friend Jas Wood in 1916 about the image, Spencer was insistent on the point: 'some people might say it had a "fine sense of solid composition", such people know nothing of the feelings that caused me to paint it. There are certain children in Cookham, certain corners of roads and these cowls, all give me one feeling only. I am always wanting to express that.'[15]

11 *Mending Cowls, Cookham* 1915
Oil on canvas
45.1 × 54.6
(17¾ × 21½)
Tate; Presented by the Trustees of the Chantry Bequest, 1962

The period between leaving the Slade, in 1912, and enlisting for war service in 1915 was one of the most productive of Spencer's career, a time that he looked back on as a kind of Golden Age, when his vision was its most intense. 'When I left the Slade,' he said, 'and went back to Cookham I entered a kind of earthly paradise.'[16] In fact he had never really left his home village. But by now, and with the outside perspective provided by his regular visits to London and back, Spencer was sure that Cookham was the source of his inspiration and the heart of his art. He worked intensely, with dedication and joy, producing such images as *Joachim Among the Shepherds* (1913) (see fig.12), *Zacharias and Elizabeth* (1913–14) (fig.13) *Self-Portrait* (1914), *The Centurion's Servant* (1914), *The Betrayal* (1914) and *Mending Cowls, Cookham* (1915). With few responsibilities and little pressure to produce work, Spencer was delighted with himself and his life at home in Fernlea. Each morning brought new possibilities. Walking to Odney Weir with a friend in these mornings, he wrote,

> I feel fresh awake and alive; that is the time for visitations. We swim and look at the bank over the rushes I swim right in the pathway of sunlight I go home to breakfast thinking as I go of the beautiful wholeness of the day. During the morning I am visited and walk about being in that visitation. Now at this time everything seems more definite and to put on a new meaning and freshness you never before noticed. In the afternoon I set my work out and begin the picture, I leave off at dusk feeling delighted with the spiritual labour I have done.[17]

Each painting produced during this period was deliberated over, dwelt upon, dwelt with, truly felt. Looking back in 1955, Spencer spoke longingly of the unforced emergence of these paintings, which by now he considered to be his best. 'As I finished one painting,' he wrote, 'I had no drawing or sketch or notion as to what would be the next painting. I only felt confident there would be something. I woo'd the empty air in front of me.' Each image came forth in an unrelated sequence in which Spencer sensed 'something auspicious like succession of children in a family'. These were pictures born of the young artist's joy in the world, images that 'kicked their way through my mind' and appeared 'as paintings of that joy'.[18] And when they were finished, many of his paintings found buyers amongst those friends and patrons he met – often through Slade connections – including Edward Marsh, Henry Lamb and Gwen Raverat. For the rest of his life he dreamed of this brief period of bliss, before he experienced the disruptive effects of either war or sex, and before financial commitments demanded that he increase his artistic production and – so he thought – compromise his vision.

At this stage in his life Spencer's needs were few, and these were catered for. His family home provided domestic comfort, security, company and meals. He found space in which to paint, in a corner of Fernlea, or in neighbours' attics and barns around the village. He liked painting in a corner of the kitchen or dining-room, even if it meant sharing it with a piano lesson, or having to move when the table was set for tea. On walks around the village he found subjects for his paintings. Back at home a selection of postcards of Renaissance

12 Study for *Joachim Among the Shepherds* c.1912
Pen and ink, pencil and wash on paper
40.6 × 37.1 (16 × 14½)
Tate; Presented by the Trustees of the Chantrey Bequest, 1955

13 *Zacharias and Elizabeth* 1913–14
Oil on canvas
140 × 140 (55⅛ × 55⅛)
Tate; Purchased jointly with Sheffield Galleries and Museum's Trust with assistance form the National Lottery through the Heritage Lottery Fund, the National Art Collections Fund, the Friends of the Tate Gallery, Howard and Roberta Ahmason and private benefactors 1999

14 *St Francis and the Birds* 1935
Oil on canvas
66 × 58.4 (26 × 23)
Tate; Presented by
the Trustees of the
Chantrey Bequest
1967

paintings 'kept him company' as he worked;[19] he also had copies of the cheap 'Gowans and Grey' editions of the works of the Old Masters. Refusing an invitation to London in 1913, he wrote to his friend Henry Lamb: 'I wish the National Gallery was in Cookham, but I have many reproductions of fine pictures of old masters.'[20] Indeed, Spencer seems to have preferred these reproductions to the real thing. Pinned up on the walls of his bedroom, his postcards became a part of his surroundings. Miniaturised in this way, the Old Masters were compositionally digestible, and Spencer delighted in placing tiny black and white photographs of his own paintings alongside the early Italian masterpieces reproduced in the pages of his Gowans and Grey books, which were small enough to fit snugly in his pocket.

Spencer liked the idea of having everything he needed within reach, as it was at Fernlea. 'I think I could have reached to all I wanted without going far from the kitchen door,' he wrote, years later, 'and I think it would have suited me to be tied to ma's apron strings.'[21] Spencer's domestic security, he tells us, was the necessary precondition for the development of his vision, and the rest of his life he would be concerned with establishing a domestic set-up compa-

rable to Fernlea within which he could thrive. After the war, his home life was never again quite so secure or so comfortable. He spent a good part of his adult life staying in other people's houses, dependent on the hospitality and good-will of patrons or friends. The first few years of marriage to Hilda seemed – at first – to fulfil Spencer's need for domestic security after 1925, but after the break-up of his first marriage and the failure of his second, he was back to his old itinerant lifestyle, living in rented rooms, hotels and friends' houses. If his own home-life left something to be desired, however, the domesticity he yearned for could be recreated in and through his paintings. 'My art,' he wrote in 1946, 'is a home-finder, for me a nest-maker. It goes to prepare a place for me.'[22]

As Spencer replaced one set of circumstances for another, as his life became more complicated, those brief periods of domestic stability – in Fernlea, particularly, and in Burghclere, where he lived for a time with Hilda – came to assume a luminous significance in his memory. The rooms, furniture, objects, doorways, passageways, garden and inhabitants of Fernlea would recur in painting after painting. The patriarchal 'Pa', for example, recognisable by his long white beard, appears in a whole series of images in the 1930s and 1940s, including *St Francis and the Birds* (1935) (fig.14). The cots in the nursery, with their enclosing railings, and a childhood game involving a procession of paper nuns are depicted in *The Nursery* (1936). In *Bridesmaids at Cana* (1935) the infant Spencer children inspect wallpaper samples under the shelter of a huge table, while in a later painting in the same series (fig.15), Christ's miracle at the Marriage at Cana is announced in the Fernlea kitchen, complete with the clothes-horse that had also appeared, forty years earlier, in *Scene in Paradise*. These pictures – along with many others – were intended to line the walls of the Church-House, a home both for Spencer's memories and his paintings,

15 *The Marriage at Cana: A Servant in the Kitchen Announcing the Miracle* 1952–3 Oil on canvas 91.8 × 152.7 (36⅛ × 60⅛) Gift of the Second Beaverbrook Foundation, The Beaverbrook Art Gallery, Fredericton, N.B., Canada

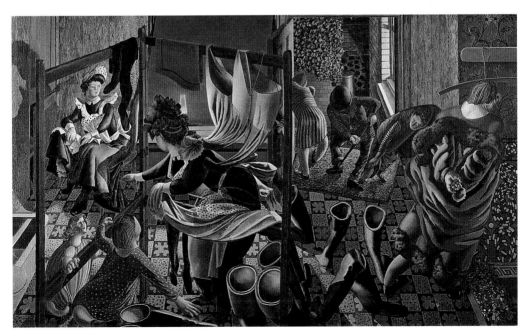

where all the displaced parts of his domestic history could come together in one all-embracing scheme, under one roof.

It was the *sensation* of being at home that Spencer loved, as much as memories of a particular house. Home, according to Spencer, was the feeling of 'holding par's hand', or being in a space between the wall and the walnut tree in the garden of Fernlea.[23] This bodily sense of being at home is often figured by images of enclosure in his paintings. In the *Domestic Scenes* series of the 1930s, for example, he is enveloped by the enclosing forms of bedding, furniture or the petticoats and flesh of ample women (figs.16, 43). One of Spencer's abiding memories was of hiding in the folds of his mother's skirts as he walked with her around Cookham, since he was a small and timid child who feared the village bullies. A home could be found here, just as it could within the clothes-horse at Fernlea, or tucked up in bed. The many figures who in Spencer's paintings are enveloped inside tent-like forms of fabric are the visual echoes of these – and other – primal memories of cosiness and security.

Spencer's attachment to the homely extended to more purely formal aspects of his work. If figures within his paintings are often enclosed within enveloping forms, whether fabric, flesh, walls or landscape, the viewer – in a sense – is similarly enclosed by Spencer's choice of composition, with its invariably high horizon. As his brother Gilbert noted, 'scarcely any of his compositions have skies; most of his designs are an enclosure'. This is true of most of Spencer's landscape paintings, such as *Cookham Moor* (1937) (fig.17), as well as his imaginative works, such as *Zacharias and Elizabeth* (fig.13). Spencer liked paintings that made the viewer feel at home in them, just as he felt at home in Cookham, itself a village girdled by a slight escarpment

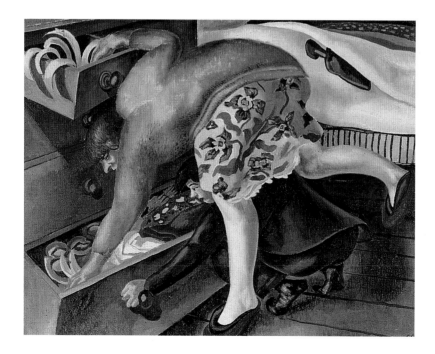

16 *At the Chest of Drawers* 1936
Oil on canvas
50.8 × 66 (20 × 26)
Stanley Spencer
Gallery, Cookham

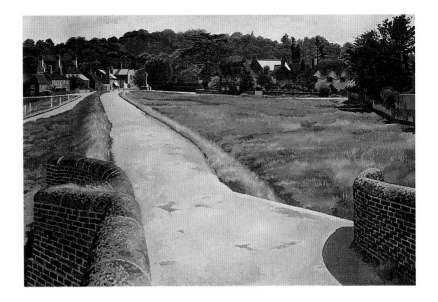

crowned by the woods at Cliveden, giving a sheltered and cosy feeling to the place. 'In Cookham, too,' continued Gilbert, 'our horizon was close, and our sky-line had the feeling to be found in so many of his pictures.'[24] The sky-line in *The Nativity*, for example, encloses both the painted figures and the viewer, echoing a whole series of other enclosures within the image – the embraces of the two couples, themselves enclosed by fences; the line of horse-chestnut blossoms, circling the waist of the Joseph figure on the right, and the enclosure of the baby Jesus in his crib (fig. 10).

'Cosy,' wrote Elizabeth Rothenstein, who knew Spencer well from the late 1930s, 'was the word most frequently on his lips when describing his paintings.'[25] This cosiness could apply to the composition of a painting, its subject matter, its associations, or its 'atmosphere'. Cosiness was all Spencer required from a working-space, too, all his life preferring to paint in his bedroom rather than in an artist's studio. Cosiness was what modernist painting all too often lacked; it was there in those penny 'Books for the Bairns' of Spencer's childhood, it was there in the framed reproductions of Victorian paintings on the walls in Fernlea; and within its high horizons, walled gardens and welcoming homes, it was there in Cookham.

2

COOKHAM

Cookham-on-Thames is situated twenty-five miles west of London, on a stretch of river accommodating a series of picturesque villages and small towns – Henley, Marlow, Maidenhead – that blend an isolated ruralism with a certain sophistication, due to the down-river proximity of the capital (fig.18). This is a part of the Thames that for a hundred and fifty years has been the playground of the leisured classes in seasonal events such as rowing regattas, and in idyllic riverside villas with private moorings, elegant lawns and topiary gardens. Since the coming of the railway and, later, the car, Cookham, like Henley and Marlow, has been a popular destination for a day out, and a desirable place for commuters to live in. But despite this, Cookham was still largely a rural economy until well after the First World War. In Spencer's youth, livestock grazed on common land in the centre of the village, fruit-growing and basket-making were major parts of the local economy, and working farms and labourers' cottages coexisted with the inns and hotels that catered for the village's holiday-makers and day-trippers (fig.19).

Cookham, then, in Spencer's childhood, was a curious and pleasant mixture. Near enough to London to enjoy the wealth and glamour brought by visiting city-dwellers, it was sufficiently distant to avoid suburbanisation. Surrounded by marshy land with a tendency to flood, with the private estate of Cliveden limiting expansion to the east of the village, Cookham seemed to the Spencer children like an island, cut off from the outside world for most of the year. Within the bounds of marsh meadows, woods and river, Cookham village itself, down the hill from Cookham Dean and Cookham Rise, and across the moor, was an aggregation of dwellings cosily interspersed with

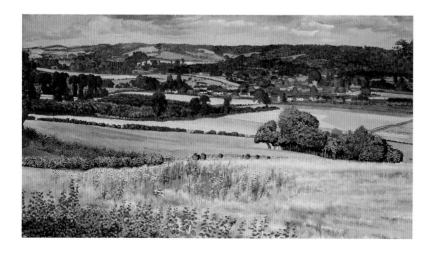

18 *Cookham from Cookham Dene* 1938
Oil on canvas
66 × 117 (26 × 46)
Bradford Art Galleries and Museums

19 Cookham High
Street, *c.*1900
Courtesy The Francis
Frith Collection

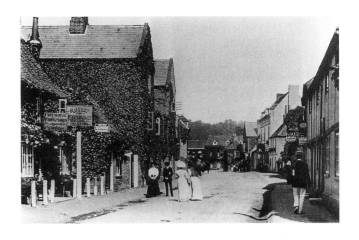

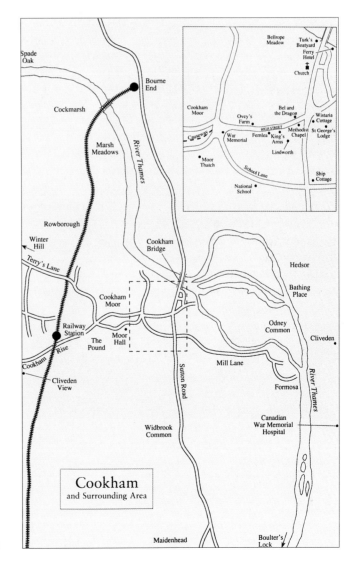

20 Map of Cookham

flower-filled gardens and unusually tall trees. Cookham was – and still is – a place where the built environment seems to coexist harmoniously with nature, where there is a pleasing and generous balance of public and private space, and an easy reciprocity of water and land (fig.20).

The topography of Cookham was indelibly imprinted on the artist's imagination. Through childhood walks and visits in the village, and through stories and gossip, Spencer had an intimate knowledge of its features and its inhabitants, many of whom were related to him and to each other. The Cookham he carried with him in his head was a map where every spot had particular associations, atmospheres, moods and meanings deriving partly from events and meetings that happened in those places, but also from an indefinable aura that suffused them. The extent to which the young Spencer had internalised Cookham is made apparent in a long letter that he sent to his friend Desmond Chute in 1917, while he was serving in the army. Far away in Salonika, Spencer reconstructed his home village and its inhabitants in a kind of mental walkabout, recorded in trance-like prose:

> I am walking across Cookham Moor in an easterly direction towards Cookham villiage, it is about half past 3 on a Tuesday afternoon ... Walking upon to the causeway between the white posts placed at the eastern end, is Dorothy Bailey; how much Dorothy you belong to the Marsh meadows, and the old village ... I can now hear the anvil going in Mr. Lanes blacksmith shop, situated on the right of the street ... The shop is over shadowed by a clump of pollarded elms which stands just outside the old red bricked wall ... Appearing above the elms & part way between them & a Ceda tree which rises from the garden enclosure formed by the wall, are Mr. Wallers malt houses with their slate roofs & heavenly white wooden cowls ...[1]

Spencer did not like to be away from Cookham for too long – he spent a total of forty-nine of his sixty-eight years there. Such was the identification of Spencer with his home village, that he was known as 'Cookham' by his fellow-students at the Slade. Cookham was more than simply the place Spencer came from, and it was far more than the 'backdrop' of his most famous paintings. Spencer's Cookham was an image-bank in his head, in which particular places and people were filed under different moods or feelings, and from which he drew elements to make up his paintings. Spencer saw Cookham as a whole as a place with a unique flavour, the mystical source of his inspiration, and the yardstick of every other place he ever visited. Later he came to think of his home village as the very 'suburb of heaven'. In Spencer's paintings, Cookham – at first the location of biblical narratives, later the site of orgies of sensual bliss – was a place of miracles and transformations, where the ordinary was blessed through the artist's intercession.

The early biblical works

The first works in which Spencer set biblical stories in Cookham, including *The Nativity*, *Joachim Among the Shepherds*, and *Zacharias and Elizabeth*, were followed after the war by a series of paintings of scenes from Christ's Passion, also set in and around the village. These included *The Last Supper* (1920), *Christ Carrying the Cross* (1920) (fig.24), *Christ's Entry into Jerusalem* (1921), and *The Betrayal* (1922–3), a subject that he had already tackled in 1914. Spencer's early paintings of biblical subjects still have the capacity to startle and enchant, fusing mythical narratives with specific and apparently unremarkable locations – a barn, a back garden, a street pavement. This concatenation of biblical and local produces some strange effects, but it is not without precedent in the history of art. Gauguin fused biblical events with rural Brittany in paintings like *Vision after the Sermon* (1888) and *Christ in the Garden of Olives* (1889), which possibly influenced Spencer's *Apple Gatherers*. In more realist mode, nineteenth-century British painters such as Holman Hunt, John Everett Millais and William Dyce all painted biblical scenes as if they had occurred in the British landscape. Hunt's much-reproduced painting *The Light of the World* showed a very human Christ knocking on an ivy-covered door in a dusky English orchard. In Dyce's extraordinary *Gethsemane* (*c.*1860) the garden of Gethsemane seems to have been transplanted to a Scottish glen (fig.21). And in paintings like *Christ in the House of his Parents* (1849–50), Millais

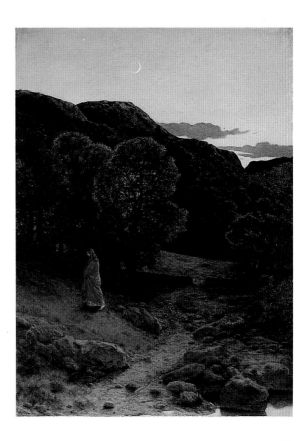

21 William Dyce
*Gethsemane c.*1860
Oil on canvas
41.8 × 31.3
(19 × 12⅜)
The Board of the
Trustees of the
National Museums
and Galleries on
Merseyside (Walker
Art Gallery,
Liverpool)

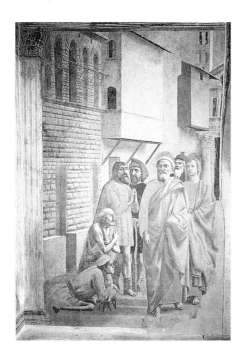

22 Masaccio
St Peter Healing the Sick with his Shadow
*c.*1427
Fresco
Brancacci Chapel, Santa Maria del Carmine, Florence, Italy

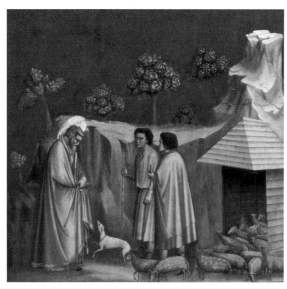

23 Giotto di Bondone
*Joachim Among the Shepherds c.*1305
Fresco
Scrovegni (Arena) Chapel, Padua, Italy

re-inscribed biblical events in lush settings more reminiscent of the British countryside than Palestine.

Spencer did not explicitly cite these Pre-Raphaelite works as inspiration, although reproductions of paintings by Millais and Rossetti adorned the walls of Fernlea, and Pre-Raphaelite art – as we have already seen – was still in vogue at the Slade. He did, however, acknowledge the example of the early Renaissance painters in Italy, who had used details of local topographies in their paintings of sacred subjects. The Italian painters' habit of filling in local

details seemed – to Spencer – to give biblical stories a homely feeling, which was why he cherished his reproduction of Masaccio's *St Peter Healing the Sick with his Shadow* (fig.22). Spencer loved what the writer Fiona MacCarthy called the 'almost nonchalant approach to the miraculous' of the early Italian painters.[2] The black-and-white reproductions in his Gowans and Grey books intensified this effect, for at a glance these could be photographs of real miracles taking place in the streets of Florence or Siena rather than photographs of paintings. And if, as he thought, Giotto could paint scenes from the Old and New Testaments as if they had occurred quite naturally in a north Italian landscape (see fig.23), then why should Spencer not localise the same stories in the Berkshire streets, fields and rooms he knew so well?

Spencer found a self-validating precedent for his paintings amongst these Renaissance artists, whose work he – like other so-called 'Neo-Primitives' at the Slade – so admired. But the relationship between story and setting was more closely fused, more deliberate, and more fully realised in Spencer's paintings than it was in the work of either the Italian Primitive painters or the Pre-Raphaelites. Looking at Giotto's frescoes of the life of Christ, for example, the viewer is left in no doubt as to the focus of attention in his paintings, next to which any background topographical detail pales into insignificance. In Spencer's biblical works, on the other hand, Cookham was never just the most convenient source of a backdrop to the main action. In many cases it is not easy to determine what, exactly, the main action is, since Spencer has given as much prominence and attention to the setting as he has done to its protagonists.

There is a startling equivalence of focus in paintings like *The Nativity* (fig.10), where foliage and flowers are painted with as much care as the infant Jesus, or *Christ Carrying the Cross*, where the figure of Christ is given no more prominence than any other figure (fig.24). It seems that Spencer has paid less attention to the Christ-figure in this picture than he has to the meticulously painted brickwork, ivy or railings that surround him, and that represent Fernlea, Belmont and 'The Nest' next door. Yet the fact that this half-hidden bearded figure is Christ the Redeemer transforms everything in the picture. By making the extraordinary part of the picture (Christ carrying the cross) no different from the ordinary part (the Cookham setting), Spencer makes the miraculous seem normal, and the normal miraculous. Likewise in *The Nativity*, it is evident that if the trees and flowers are real, then so too is the birth of Christ. Either everything here is sacred, or nothing is. By placing these biblical stories in the here and now, putting them on an equal footing with paving stones, meadows and villagers, Spencer does not so much de-sanctify religious themes as confer grace on the beloved landscape and inhabitants of his home village. In this sense, the explicitly biblical components of Spencer's paintings are a kind of device to express his 'feeling for things being holy'.[3]

One of the formal means through which Spencer manages to convince the viewer of this holiness of things, is by painting certain objects or figures in such a way that they appear simultaneously real and divine. Take, for example, the people looking out of the windows at Christ as he goes past in *Christ Carrying the Cross*. Spencer has painted the curtains so that they seem like

wings, transforming the figures into angels at the moment that Christ walks past. But these figures are not quite angels, any more than the curtains *are* angels' wings. Instead, just at this moment, they are both human *and* divine, and the curtains are both domestic *and* heavenly. Both aspects are equally important; neither is privileged. This device of making ordinary objects look like extraordinary objects *whilst still retaining their everyday identity* was one of Spencer's favourite tricks. It adds to the revelationary quality of his works, as if Christ walking past were enough to change curtains into wings, just as he famously changed water into wine. It formally parallels the central mystery of Christianity, Christ's identity as both human and divine, and the paradox of the Eucharist where bread and wine are also and at the same time the body

24 *Christ Carrying the Cross* 1920
Oil on paper
153 × 142.9
(60¼ × 56¼)
Tate; Presented by the Contemporary Art Society, 1925

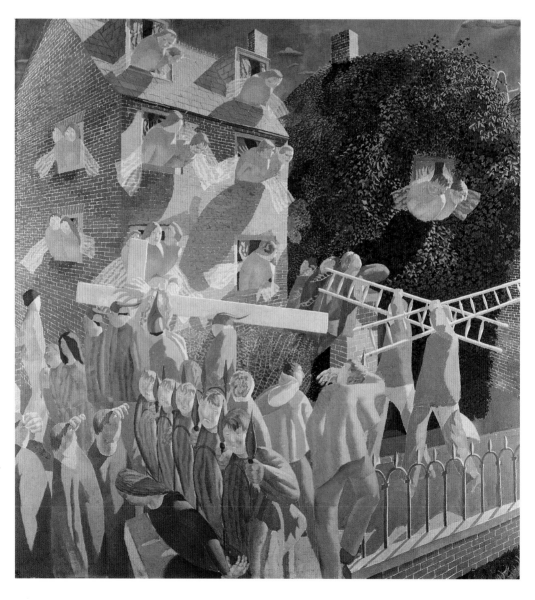

and blood of Christ. But it remains a painter's device, something that the artist could do himself. It enabled Spencer to infuse every worldly thing that he loved with a holy aspect, without taking away its worldliness. And it also allowed him to suggest in his paintings that miracles can occur – almost involuntarily – within a world of common reality.

Spencer's early paintings of biblical stories are images of revelation, where the sacred is perceived in our very midst, as if we might come across the birth of Christ on a walk in the country, or bump into a character from the Old Testament on our way to the shops; as if miracles go on all the time, unregarded, behind the high walls of gardens. This sense of revelation is there, of course, in the Bible itself, which is full of angels in disguise. But in Spencer's paintings it also derives from the secret topography of Cookham, and the artist's childhood experiences in the village. According to his brother Gilbert, the 'mood' of Spencer's early pictures may have its origin in walks they took as children with their sister Annie, 'in which so much was hidden or only half-glimpsed through fences or partly opened gates'.[4] Spencer was fascinated by those parts of Cookham that remained unknown to him: houses he had never entered, secret gardens that he could only imagine. 'To me as a child,' he wrote,

> a grand house is sometimes a sort of Heaven and as a child I used to peep through chinks and cracks in fences etc and catch glimpses of these Gardens of Eden of which there was a profusion at Cookham. From these glimpses I used to get I assumed that some sort of saint or very wonderful person lived there and so on. If I was not sure of that I invented and invited Biblical Characters to take over. That is what has taken place in the 'Zacharias and Elizabeth' painting.[5]

Vestiges of the Cookham walls that separated the known from the unknown appear in *Zacharias and Elizabeth* and *The Nativity* (figs.13, 10). Walls and other barriers recur throughout Spencer's work, both as a memory of those early walks with Annie, and as a device to separate and enclose a significant action or event, as they do in *The Meeting* (1933) (fig.25), which commemorates Spencer's first encounter with Patricia Preece, who became his second wife. Sometimes railings perform this dividing function, as in *Christ Carrying the Cross*, and *Two Girls and a Beehive*, where they form a barrier between the Cookham girls and the shadowy shepherd figure, identified by Spencer as Christ (fig.7). As Gilbert attests, cast iron railings were very much in vogue in the Cookham of his childhood, including those that ran along the front of Fernlea and Belmont, put in place by their grandfather. As a pictorial device they had the benefit of allowing space to remain visible at the same time as being curtained off – they simultaneously reveal and conceal. And as elements of his home environment with a family connection, the presence of railings in a picture might instantly introduce that 'Cookham-feeling' that Spencer strove so hard to maintain in his work.

If Spencer's first paintings of religious subjects derived from his early walks around Cookham, they owed as much to his knowledge of biblical narratives. In a sense these pictures are the visible result of a dialectic of reading and

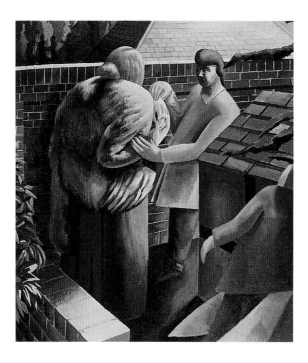

25 *The Meeting* 1933
Oil on canvas
63.5 × 61 (25 × 24)
Private Collection,
Toronto

walking. At home in Fernlea, in church or chapel, he filled his imagination
with the Old and New Testaments, the Psalms and *Pilgrim's Progress*. There
was a 'richness' underlying the Bible, that Spencer could also see 'in Cookham
in the hedges, in the yew-trees'.[6] To the young artist the Bible and Cookham
had a secret affinity. The stories he read at home and the places he knew in
Cookham seemed to complement each other in some mysterious way; and he
began to map the world of the Bible onto the streets, fields and gardens of his
home village. 'I liked to take my thoughts for a walk,' he explained, 'and marry
them to some place in Cookham.'[7] Spencer's biblical paintings are the visible,
lasting record of this marriage between interior thought and external place.
For Spencer, his paintings succeeded to the extent that the marriage was a
happy one; revealingly he compared his landscape paintings to 'women I have
failed to marry. Something has only been indicated and not consummated in
them.'[8]

One example of a happier 'marriage' between story and place is *The
Betrayal* (1922–3) (fig.26). In this painting the garden of Gethsemane where
Judas betrayed Christ has been fused with the bottom part of the Fernlea
garden. This was a part of their environment that the young Spencer and his
brother Gilbert thought of as 'sinister', where rubbish was deposited, and
where at night the distant lights from Maidenhead created a depressing glow.
In its associations it was for Spencer therefore an appropriate location for
the betrayal of Christ, which according to St John happened in a garden, at
night. In Spencer's painting an infant Stanley and Gilbert cower behind the
corrugated wall of the schoolroom, and the disciples line up behind the flint
wall, witnesses to the scene described in John 18, where Simon Peter strikes
the high priest's servant and cuts off his ear.

Spencer's habit of mapping biblical narratives onto real space and real people was almost compulsive. Describing the feeling he got when he saw the maid descending from her room in the attic at Fernlea, for example, he said: 'I would not have been surprised to see her face shine as Moses did when he came down from Mt. Sinai.'[9] The maid's room was out-of-bounds to the Spencer children, and this lent it a mystery similar to that of Cookham walled gardens, which led the artist to set *The Centurion's Servant* in this room in 1914. In particular, Spencer was predisposed to perceive 'heavens' all around him – at Finchley station, in a hospital ward, and especially in Cookham. Certain aspects of his religious upbringing (which Gilbert tellingly described as a 'mixture of rationalism and mysticism') encouraged him to give a geographical location to the heavenly realm.[10] Bunyan's *Pilgrim's Progress*, which the Spencer children read at home, mapped the journey of the soul as a journey through space, a seamless – if perilous – trip 'from this World to that which is to come'. Methodist preaching also tended to imagine the soul's path through life in geographical terms. But if the Methodist route to heaven was along a steep and rocky path, Spencer did not concur. In his memoirs

26 *The Betrayal*
1922–3
Oil on canvas
122.7 × 137.2
(48¼ × 54)
Trustees, Museums
and Galleries of
Northern Ireland

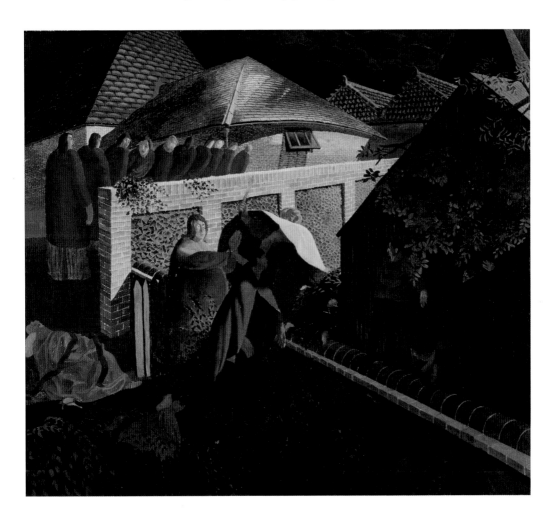

Gilbert describes the arrival in Cookham of a revivalist who parked his caravan in a yard by the boathouse, and set up a black banner emblazoned in gold with the words 'Where Will You Spend Eternity?' For Spencer, the answer was obvious: right here.

The Cookham Resurrection

In 1924 Spencer confidently began to work on the painting that would make his name as an artist. *The Resurrection, Cookham* was an image conceived on a huge scale, and in almost cinematic format. This very literal interpretation of the Christian doctrine of the resurrection of the body is set in the grounds of Holy Trinity Church in Cookham. Figures – including Cookham parishioners, Spencer's friends and family, a group of Africans, and the artist himself – lazily emerge from their graves as if waking after a long sleep. To the left of the church some of the resurrected are climbing over a stile; others are making their way down the river on one of the pleasure boats that were such a familiar sight along this stretch of the Thames. An unprepossessing God-figure lolls in the church porch, behind a figure who is meant to be Christ, holding some small doll-like figures. Saints line up along the church wall, unsurprised by the extraordinary event unfolding in front of them.

This is an unusual subject for a painting, but it united many of Spencer's favourite pre-occupations. He had been working on a resurrection theme for some time. In 1914–15 he had painted a diptych entitled *The Resurrection of the Good and the Bad*, and a painting of 1920-1, *The Resurrection, Cookham*, like the later work, showed figures emerging from their graves in the Cookham churchyard. In all these images of the Last Day, there is no adverse judgement of the resurrected. Instead, all the figures – the 'good' and the 'bad', the old and the young, the Christian English and the heathen Africans – emerge from the ground into the pleasant atmosphere of Cookham on a summer's day. They lounge around, smell flowers, gaze at their surroundings, meet old friends, as if it were the most natural thing in the world to rise from the dead. Some resume the roles they played in their lifetime: a woman brushes the earth off her husband's jacket, friends exchange letters. These people have been reborn not into a different world, but into this world, the world of mayflower, pleasure-cruisers, tweed suits and family ties.

In a sense, then, Spencer's painting is not so much a representation of the afterlife, as an image of the heavenly potentiality of this life. Spencer took John Donne's metaphorical description of a churchyard as 'the holy suburb of heaven' and audaciously literalised it. Heaven is not beyond us, waiting for us after death, but this is heaven and we are in it, if we could only realise it. Those who are resurrected in *The Resurrection, Cookham*, according to Spencer, find 'new meaning ... in what they had seen before'.[11] The motif of the resurrection was arguably, then, a defamiliarising device for the artist, as these figures see their surroundings and their loved ones, grown stale through familiarity, as if for the first time. They brush the dust from their eyes, and see – as Spencer saw – the joy to be felt in the here and now, in human relationships and in the hedgerows of Cookham. Resurrection, for Spencer, was not

just part of orthodox Christian teaching. It could be used pictorially as a way of expressing new-found joy in our lives and our surroundings, and the physical process – akin to waking from sleep – through which this joy comes to be experienced. Spencer loved Cookham; calling it 'heaven' was his way of saying just how much.

Spencer's *Resurrection* is an image in which everyone experiences a kind of transformation; and it was this aspect of the painting that he later took to be the most significant. 'In this life,' he explained, 'we experience a kind of resurrection when we arrive at a state of awareness, a state of being in love, and at such times we like to do again what we have done many times in the past, because now we do it anew in Heaven.'[12] Looking back, Spencer interpreted *The Resurrection, Cookham* as the first of his 'sex pictures', signifying the end of one era of painting, based on the 'Cookham-feeling', and the beginning of another, based on sex. Halfway through painting this picture, Spencer married Hilda Carline and was initiated into the world of sex. This he experienced as a kind of rebirth, and interpreted as the advent of a new life. Seen through these eyes, the figures in this painting are not only resurrected; they are also

27 Sarah Tubb and the Heavenly Visitors
1933
Oil on canvas
91.4 × 101.6
(36 × 40)
Stanley Spencer
Gallery, Cookham

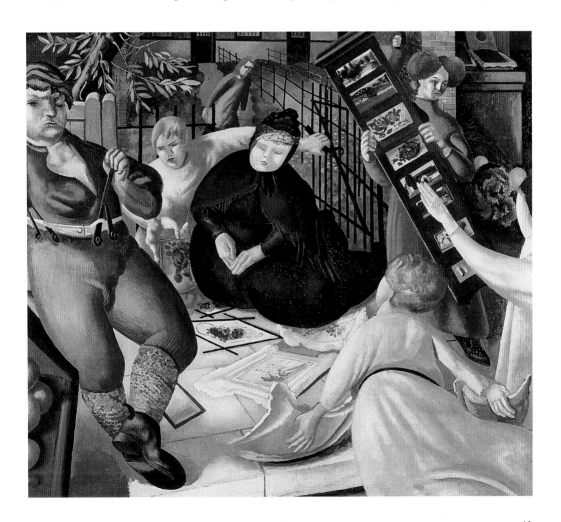

41

post-coital, lazily pushing up the grassy mounds of innocence, and dreamily contemplating their new lives in love.

The people who are resurrected in *The Resurrection, Cookham* are transfigured as human beings. They are somehow different, whilst staying the same, just as the curtain-forms in *Christ Carrying the Cross* remain curtains at the same time as they are transformed into angels' wings. For Spencer, the act of love brought with it exactly this curious and sublime transmutation of body and spirit. As a child he had witnessed comparable human transportations in the Methodist chapel in Cookham. Spencer described the Methodist services as a stimulation to him as a painter:

> Being 'sanctified' was the way they had of expressing themselves. When they felt in that state, they would go and flop down just under the auditorium. I felt I should not look, but though my eyes were down I was trying to imagine what shape they were on the sacred piece of ground where they were 'coming to the Lord'. It was a patch of hard linoleum with only room for one man at a time. It seemed to me the taking off place for the Wesleyan heaven. When I heard someone pass by my pew and get down there I felt it was a sort of apotheosis of the grocer or confectioner or whoever it was.[13]

In the mid 1930s, as part of his Church-House project, Spencer devised a series of 'Last Day' paintings, in which Cookham and its inhabitants are transfigured by the Second Coming of Christ, and the dawning of a new world – which in essence is this world, seen in its most heavenly aspect. In *Sarah Tubb and the Heavenly Visitors* (1933) (fig.27), and *The Dustman* or *The Lovers* (1934) (fig.28), Cookham villagers are shown transported into a heavenly state, just as the young Spencer had witnessed the 'apotheosis' of familiar villagers, 'coming to the Lord' in the Methodist chapel of his childhood. Sarah Tubb and the dustman are reborn into their own lives: supplicating figures offer them the ordinary objects that surrounded them in their worldly existence – postcards, teapots, the flotsam and jetsam of their ordinary lives, that now have a renewed significance. As in *The Resurrection, Cookham*, everything and everyone is redeemed in these pictures, right down to the mouldy cabbage that is presented to the rather startled-looking dustman in *The Dustman*, as he lies in the arms of his equally overwhelmed wife.

Again, the idea of the Last Day can be seen as a device on the part of the artist to express his love of Cookham and its inhabitants. Unlike traditional Last Judgements, in which only some are saved, Spencer's Last Day sees the arrival of the Apostles, who bless and take part in the ordinary daily life of Cookham. The angelic visitors in *Sarah Tubb* and *Villagers and Saints* (1933) (a picture in the same series) are stand-ins for Spencer himself: 'I think these holy men or disciples or what not are just emissaries sent from me to the Rag bone men and marble players and Sarah Tubs and Dustmen, just to show them what I feel about them,' he wrote.[14] Many of Spencer's works in the 1930s and 1940s would include figures like these (often with a strong resemblance to 'Pa') as a means of blessing whatever is being depicted, and therefore unambiguously indicating the artist's own feelings.

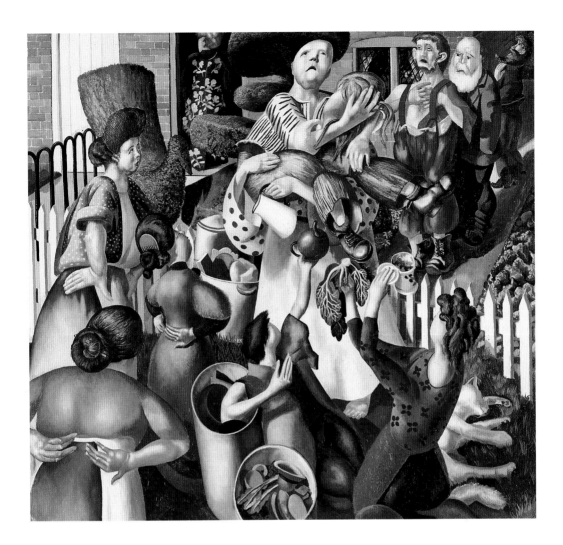

28 *The Dustman* (or
The Lovers) 1934
Oil on canvas
115 × 123.5
(45¼ × 48¼)
Laing Art Gallery,
Newcastle upon
Tyne (Tyne and
Wear Museums)

The expression on the face of the dustman reunited with his amply propor-
tioned wife in *The Dustman* treads a thin line between spiritual transportation
and sexual ecstasy. That this was intentional is indicated by the fact that
Spencer gave this painting the alternative title of *The Lovers*, and described the
blissful union of the dustman and his wife at great length and in sensuous
detail. In other works designed for the Church-House, painted around the
time of his second marriage, the line between spiritual and sexual ecstasy was
crossed altogether. Spencer came to imagine the 'Last Day' as a day on which
all differences would be erased, social and sexual boundaries would be crossed,
as we would all dissolve into each other in orgies of sensual bliss. These orgies
he imagined as taking place in particular on Cookham Moor, that most public
of spaces in his home village. The Moor is the setting for the orgiastic scenes in
A Village in Heaven (1937), for example, presided over by a phallic Cookham
war memorial and a by-now-familiar blessing figure (fig.29). Teachers hurry
schoolchildren away as villagers meet, embrace, and lie supine on the ground
amongst the roots of trees. In *Love on the Moor*, begun in 1937, villagers simi-

larly congregate on Cookham Moor, give each other gifts, touch and disrobe, in a fête of mutual adoration (fig.30).

In these works, Spencer made Cookham into a sex-heaven where everyone – young and old – is redeemed through unrestricted and public sexual love. Spencer painted these images at a time when – as we shall see in the next chapter – he was gripped by the idea of having more than one wife. Sex was surely heaven on earth; why should it be private, and why restricted to one woman? If Spencer wanted to paint Cookham in its most heavenly aspect, then its inhabitants would have to bring down those social and sexual boundaries that kept them apart. 'There is no one saying no in my pictures,' he wrote excitedly, 'all are saying yes.'[15] Spencer could not see why orthodox Christianity should be so puritanical about sex. At his most enthusiastic, he saw sex as an essential part of his religious vision. The Church-House project was designed to bring together the twin joys of innocence and experience in a single sacred building. But Spencer's sexual drive came to be a disruptive force in his personal life, and he blamed it for distorting the pre-sexual clarity of his vision – associated with home and with Cookham – that he deemed essential to his art. At various points Spencer tried to resurrect the biblical Cookham of his childhood, notably in the 1950s, in paintings such as *Christ in Cookham* (1951–2)

29 *A Village in Heaven* 1937
Oil on canvas
45.7 × 182.9
(18 × 72)
Manchester City Art Galleries

30 *Love on the Moor*
1937–55
Oil on canvas
79.1 × 310.2
(31⅛ × 122⅛)
Fitzwilliam Museum, Cambridge

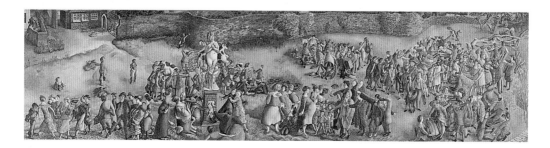

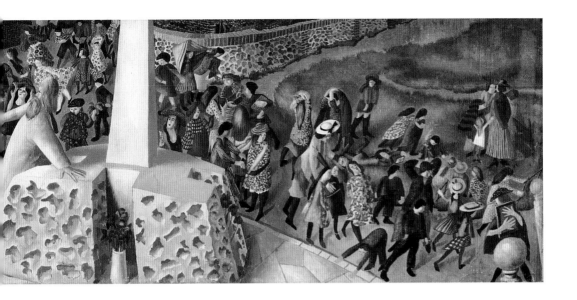

(fig. 31). But after the early 1920s, he felt himself changed in some way – a fact that he sometimes attributed to the effects of marriage, and sometimes to his experiences in the First World War. At any rate, it was not easy to maintain a childlike religious vision when one was being hounded by the Inland Revenue, with two estranged wives and two young daughters to support, which was the alarming situation Spencer found himself in by the late 1930s.

31 *Christ in Cookham* 1951–2
Oil on canvas
127 × 205.7
(50 × 81)
Watson Bequest
Fund 1952, Art
Gallery of New
South Wales, Sydney

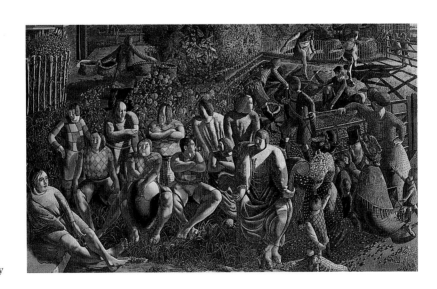

3

LOVE, SEX AND MARRIAGE

The joys of sex came late to Spencer, but they came like a revelation. 'The first time I deliberately touched a woman' – apparently not until his early thirties – Spencer knew that 'here was a miracle I could perform'.[1] Stanley realised that in order to make 'a new ma and par' and 'a new Fernlea' he would have to marry; but he was unprepared for the transformations of himself and his lifestyle that cohabitation with a woman brought with it. In some ways sex seemed to Spencer to be the fulfilment of a promise, its sensuousness and fusion prefigured by the young artist's ecstatic absorption in marsh meadow flowers and sunlit water in Cookham. Sex dissolved the boundaries between his self and another in a way he had longed for. But it also disrupted his precious sense of self. 'From that day onward,' he wrote, 'what I had always understood as being Stan Spencer was now no longer so – a whole heap of stuff lust or what you will was sweeping me along helpless.'[2] The turning-point came with his meeting with Hilda Carline.

The Carlines were a family with a long-standing involvement in the arts. Hilda, like her brothers Sydney and Richard, and her father George, trained as a painter. In the 1920s the Carline family home in Hampstead was at the centre of a circle of artists and intellectuals, where well-attended meal-time gatherings were accompanied by intense discussions that continued well into the night. It was at one such dinner party in December 1919, over a tureen of soup, that Spencer met Hilda. There followed an intermittent courtship, and a proposal of marriage from Spencer, on a painting holiday in Bosnia with the Carlines. According to Hilda, Spencer broke off and renewed their engagement six or seven times. But eventually (he was 33, she was 35) they married on 23 February 1925 in the village of Wangford in Suffolk.

Spencer and Hilda began their married life in the studio in Hampstead's Vale of Health where Spencer had already begun work on *The Resurrection, Cookham*. Hilda appears in this painting three times, lying on an ivy-covered tomb, smelling a flower in a well-washed jumper Spencer particularly liked (fig.32), and wandering over a stile towards the river. Conditions were cramped, but Spencer later remembered these early days of marriage with great affection, as the newly-weds 'groped our way peacefully about each other' in wonder.[3] In November 1925 Hilda gave birth to their first child, Shirin. In May 1927 the family moved to Burghclere in Hampshire, where Spencer had been commissioned to paint the interior of the Sandham Memorial Chapel. In the summer of 1930 a second daughter, Unity, was born.

As Spencer's artistic reputation increased, however, the cracks began to show in his marriage. He was often irritated by his wife, who seemed increasingly lethargic. 'You ... became more & more wretched & hang dog & lacka-

32 *The Resurrection, Cookham* 1924–7 (detail)
Oil on canvas
274.3 × 548.6
(108 × 216)
Tate; Presented by
Lord Duveen, 1927

daisicle every day,' he wrote to her early in 1929.[4] By all accounts, Spencer was a tireless talker, especially on the subject of his work. Young people, many of them attractive, came to visit the famous artist at Burghclere, and listened, rapt, to his talk. Hilda, on the other hand, did not always respond to his ideas in the way in which he would have liked. She did not always seem interested, although sometimes she tried; occasionally she fell asleep. In any case, she had her own ideas, especially on the subject of religion. Hilda stubbornly held to her Christian Science beliefs, much to Spencer's annoyance. 'You are not moved by me you have given a thing called God that job,' he told her angrily. 'You cannot serve Stanley Spencer & Christian Science.'[5]

Hilda was clearly exhausted during the Burghclere years, and quite possibly depressed. Her exhaustion enraged Spencer, who declared he was left to do all the housework and childcare as well as trying to paint. She abstained from sex for long periods on Christian Science grounds – or so he later claimed. And despite her artistic training, she had also largely given up painting in favour of gardening, much to her husband's annoyance. Just before the birth of Unity, Spencer wrote to his wife: 'You can't expect to have any harmony which is what you & I both want between us when to my symphonic efforts you keep up a dreary beating of old tin cans which is all your sewing & gardening means to me.'[6] Hilda's considerable talent is demonstrated in the portrait she painted in 1929 of their maid at Burghclere, Elsie Munday (fig.33). Spencer loved this picture so much he kept it with him until the end of his life. But if he actively encouraged Hilda's creativity, their domestic situation sadly seemed to vitiate it.

To make matters worse, Hilda was absent from Burghclere for long periods of time, particularly to attend to her family in London. In any case, neither of them was strong: Spencer suffered from painful kidney stones until they were finally removed in 1935. But perhaps most damaging of all, throughout these

years their relationship was subjected to constant and close self-scrutiny. Letters between them, begun well before their marriage, left no aspect of their relationship unexamined. The letters to Hilda veer from a frankness that was often cruel ('I don't think I should get a bit keen on you physically if it was not for my spiritual feeling about you') to warm declarations of love ('you are the most secret & greatest joy of my life'), sometimes within the space of a paragraph. His drawings of his wife are undeniably tender (fig.34). But Spencer demanded a total commitment and absorption in his world, his talk and his pictures, that Hilda was not always willing or able to offer, a fact that disturbed and infuriated him. He had hoped that his relationship with Hilda would connect him to God through a perfect spiritual and physical union, the necessary condition for the development of his art. Sometimes, especially when Hilda was away in London, he still imagined this to be possible. The physical *fact* of Hilda, however, her inertia, her abstinence and her antagonistic views vexed him, leading him in 1929 to long 'for some healthy (spiritually & bodily) girl that would be a comfort to me & give me all the things that in your present state you have not apparently been able to give'.[7] Such a girl he found – or so he thought – in Patricia Preece.

Spencer had met Patricia Preece in a teashop in Cookham in 1929. Patricia lived with her friend Dorothy Hepworth in Moor Thatch, a cottage by Cookham Moor bought for them by Dorothy's father. Patricia and Dorothy had met at art school, and were lovers. They had spent time in Paris, and a faint air of urban sophistication lingered around them. Their home contained literature forbidden in England but available on the Left Bank, such as James Joyce's *Ulysses*. Patricia's appearance was glamorous by Berkshire standards. Yet despite these elegant trappings, after Dorothy's father's death in 1930, the pair had fallen on hard times.

When in January 1932 the Spencer family moved to Cookham, Spencer renewed his acquaintance with Patricia. He soon became infatuated with her, a fact which he discussed quite openly with his wife. Whereas Hilda was sluggish and opinionated, Patricia seemed to be genuinely fascinated by his ideas. Stanley was flattered by Patricia's attention, and aroused by her overt femininity. His wife was homely and comfortable, but Patricia's urbane elegance

33 Hilda Carline
Elsie 1929,
Oil on canvas
172.7 × 81.3
(68 × 32)
Royal Pavilion,
Libraries &
Museums, Brighton
& Hove

excited him: 'her high heels & straight walk used to give me a sexual itch,' he later told Hilda.[8] Furthermore, he believed it to be highly significant that he had met Patricia in his home village. Patricia was surely the very *personification* of Cookham, and therefore the conduit to his pre-marriage Cookham self. A union with Patricia would reunite the artist with his vision, lost during the years spent with Hilda. Spencer had always worried that Hilda and Cookham somehow were opposing influences. Patricia, however, was both sex and Cookham, both exotic and familiar, the apparition in furs and heels amidst the walled gardens that Spencer painted in *The Meeting* (fig.25).

In the autumn of 1932 Hilda went to London to nurse her brother George, who was seriously ill. While she was away, Spencer continued to battle with his feelings for this woman who, according to Hilda, 'vamped him to a degree unbelievable, except in cinemas'.[9] He grew closer to Patricia. Hilda felt disinclined to return home to Cookham permanently; with great forbearance she wrote to her husband in 1933: 'I am tremendously anxious ... for you to have what you need and want. I am so much more anxious for that, than that I should have any of my personal wants.'[10] By the mid-1930s, Spencer had decided that what he needed and wanted was to marry Patricia. She was an appropriate sort of wife for an artist of his standing, after all. She was stylish and charming; she responded to his ideas; she was socially adept and well con-

34 *Portrait of Hilda*
1931
Pencil on paper
50.8 × 35.2
(50.8 × 13⅞)
Scottish National
Gallery of Modern
Art

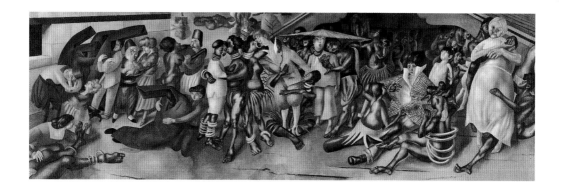

nected. She seemed to Spencer – who, growing up in Cookham, had always been highly aware of class distinctions – to be a 'nob', his social superior. 'My affair with Patricia is my one & only social achievement,' he informed Hilda in July 1934, 'the true & correct reward for all the *best* work I have done.'[11]

Spencer's mounting sexual excitement found an outlet, in the 1930s, in a series of paintings celebrating the act of love, pictures that astonished the few who saw them, and perturbed his dealer, who found them difficult to sell. *Love Among the Nations* (1935), for example, is an extraordinary image in which physical love 'breaks down the barriers' between representatives of the nations of the world (fig. 35). Spencer himself is represented in the painting: two nubile half-naked Africans pull on the buttons of his tweed jacket, with amorous intent. Elsewhere in the picture an elderly and toothless white woman is stroked and held by another pair of Africans, whilst Chinese, Turks and Moroccans engage in the foreplay to a mass orgy of lovemaking of the sort Spencer had imagined while fighting in the First World War: 'During the war, I felt the only way to end the ghastly experience would be if everyone suddenly decided to indulge in every degree or form of sexual love, carnal love, bestiality, anything you like to call it. These are the joyful inheritances of mankind.'[12] The same sexual abandonment is celebrated in *A Village in Heaven*, *Love on the Moor*, and *Sunflower and Dog Worship* (1937) where humans, animals and plant life embrace and lick each other (fig. 36).

35 *Love Among the Nations* 1935
Oil on canvas
95.5 × 280
(37⅝ × 110¼)
Fitzwilliam Museum, Cambridge

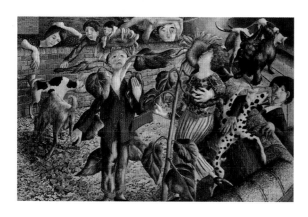

36 *Sunflower and Dog Worship* 1937
Oil on canvas
69.8 × 105.4
(27½ × 41½)
Private Collection

Spencer's own participation in the 'joyful inheritances of mankind' during these years was probably rather meagre, in contrast to that enjoyed by the figures in his paintings. In many ways his 'sex pictures' must have acted as compensation for the limited nature of his sexual relations with Patricia, whose teasing 'love-games' apparently did not generally extend as far as Spencer would have liked. When they did finally attempt to make love she obviously was not keen. 'As to giving herself to me,' wrote Spencer, 'she removed all of herself up into her head which she buried in a pillow, and sub-let the rest of her shifting body ... at high rental.'[13] Such was his infatuation, however, that he persevered. He was still sharing his feelings with Hilda. In a letter written in 1936 he told her: 'the more severe and austere [she is] the bigger the thrill. Every inch I gain with Patricia is real achievement – it is so extraordinary to get near *at all*.'[14]

Spencer painted two remarkably honest – if obscure – records of his relationship with Patricia: the *Self-Portrait with Patricia Preece* of 1936 (fig. 37), and in the following year, just before their marriage, the *Double Nude Portrait: The Artist and his Second Wife* (also known as the *Leg of Mutton Nude*). There is nothing in the history of British art quite like these pictures, which were rarely exhibited in Spencer's lifetime (and it has not been possible to obtain permission to reproduce the *Leg of Mutton Nude* here). Not until Lucian Freud would a British artist again explore the material nature of human flesh with such stark realism. Like Freud's work, these pictures are still-lifes of flesh, yet there also seems to be some kind of submerged narrative here, hard to read. Why do their eyes not meet? What is the leg of mutton doing there? For an

37 Self-Portrait with Patricia Preece 1936
Oil on canvas
61 × 91.5 (24 × 36)
Fitzwilliam Museum, Cambridge

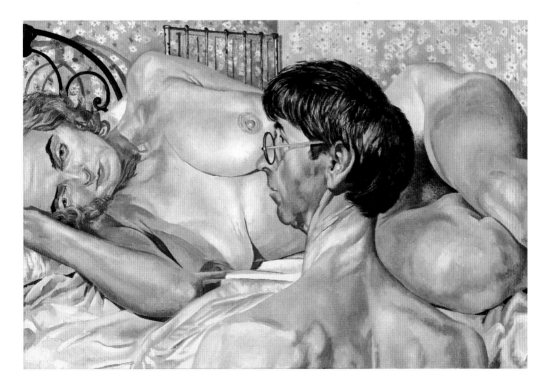

artist so keen on communion and fusion they are grim images indeed. These bodies are not 'saying yes' to each other. In the *Leg of Mutton Nude* Spencer's penis is flaccid, he still has his glasses on; Patricia stares blankly past him. Here 'there is ... male, female and animal flesh',[15] as Spencer remarked, but there is nothing to indicate the *transformation* of that flesh through sex. These figures are neither post-coital nor pre-coital; they seem more like the meticulous record of a botched attempt at intimacy.

Spencer painted a number of portraits of Patricia nude or wearing lacy lingerie in the mid-1930s, and it is likely that the *execution* of these images – unusual in Spencer's oeuvre – was a substitute for sex, as much as anything else. Spencer later told Hilda that he and Patricia were not having sex 'during all the years when I was doing those nudes of her and myself'.[16] If he couldn't have Patricia, he could at least relish her flesh through slow and close observation whilst she posed for him (fig.38). Spencer compared his intimate scrutiny of Patricia's neck, breasts and downy belly with the view of an insect crawling over her body. And once he had finished, possessing Patricia's naked image could function as a surrogate for her real presence, and consolation for his frustration.

Patricia's interest in Spencer seems to have been financial and social rather than sexual. Her economic future with Dorothy was as uncertain as their social respectability in the village was dubious. Patricia acted as a kind of agent for Dorothy's paintings, which – bizarrely – she passed off as her own work, but this did not solve their financial problems. When Spencer and his family came to live in Cookham, initially Patricia and Dorothy were concerned that his presence might take away their livelihood, and they dreaded the visits of this man with his tedious chatter. Financially, things were getting desperate for Patricia, however, and she must have seen how Spencer's obvious interest in her could free her from the poverty she feared.

Taking advantage of Spencer's weakness for her, Patricia set herself up as his agent and encouraged him to paint more of his lucrative landscapes, which she would then take to London, where his dealer Dudley Tooth would sell them. Spencer's landscape output increased enormously during the 1930s, as he took to painting meticulous and deadpan views around Cookham (fig.39), including the blooming gardens of wealthy Cookham inhabitants, for each of which, supposedly, he was rewarded with the honour of kissing Patricia's hand. These landscapes, unlike his nudes or his imaginative works, were sure of a buyer, and Spencer could not paint them fast enough, because by 1935 he was becoming seriously in debt. According to him, Spencer spent between £1,200 and £2,000 on gifts for Patricia in the years before their wedding – a huge amount at the time. It pleased him to buy Patricia clothes and jewels, and it excited him to dress her up in them. The motif of the gift, a symbolic prelude to sexual relations, appears in a number of Spencer's works, including *Love on the Moor*. Gifts of stockings, necklaces or petticoats were his tribute to Patricia, his offering at the altar of love, but it cost him – and his estranged family – dear. In February 1935 Spencer wrote to Hilda to ask if she could manage on 30 shillings less per week, since 'I like to spend money on what I *love* to spend it on & what I feel deserves to have it. But to have to pay

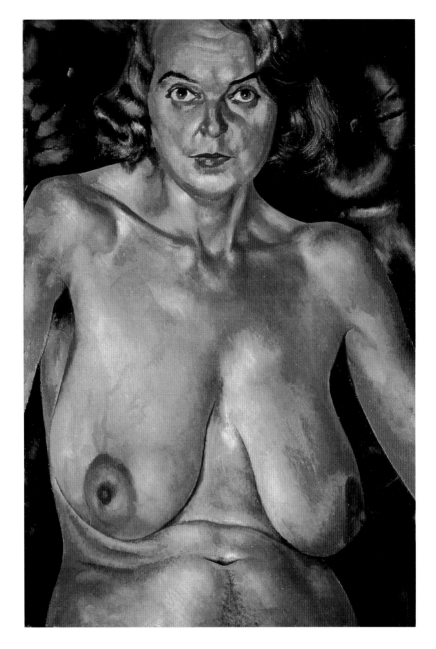

38 *Nude (Portrait of Patricia Preece)* 1935
Oil on canvas
75.2 × 50.8
(30 × 20)
Ferens Art Gallery:
Kingston Upon Hull
City Museums and
Art Galleries

only because of a moral obligation to do so is not very nice & like Income Tax I like to pay only what they have a right to demand.'[17] Hilda was devastated, and even more so when Spencer signed their family home, Lindworth, over to Patricia. 'Physically and mentally I am going under,' Hilda told her husband,[18] and in 1936 she reluctantly initiated divorce proceedings.

On 29 May 1937 Spencer and Patricia married at Maidenhead Registry Office. A telling photograph commemorating the occasion shows a glamorous but tense Patricia standing next to her new husband, and a distinctly disgruntled Dorothy by her side (fig.40). The extraordinary drama that unfurled

after this photograph was taken has been subject to different interpretations, but it seems that Spencer was from the start determined to maintain married relations with both Hilda and Patricia, and that Patricia herself, with much to gain, went along with his scheme – although she had a hidden agenda of her own. The only person who was not in on this pre-nuptial arrangement was Hilda.

It had been planned that Spencer and Patricia should go to St Ives in Cornwall after the wedding, as a kind of honeymoon-cum-painting trip. Patricia and Dorothy went to St Ives in advance, and Spencer was to join them a few days later. In the meantime, Hilda had been invited by Patricia to go to Lindworth to collect her personal belongings, and, if she wished, to come on to St Ives with Spencer. Arriving in Cookham, Hilda was surprised to see Spencer still there, but he assured her that Patricia would not mind if she spent the night in their former home. They slept together; Spencer was overjoyed, for it seemed that his plan might work. Explaining to Hilda that he intended to live with both her and Patricia, and that Patricia was in agreement with this plan, he was disappointed to find that Hilda did not share his enthusiasm for it. He went alone to St Ives to join his new wife, while – extraordinarily – Hilda remained in Lindworth to do some spring-cleaning in preparation for the return of the newlyweds. It seems, however, that Patricia was not happy to hear that Spencer had resumed sexual relations with Hilda. She was so shocked, she said later, that she refused to cohabit with him in the cottage at St Ives, retiring instead to Dorothy's room. The marriage, in all probability, was never consummated. Spencer spent the remainder of the six weeks in St

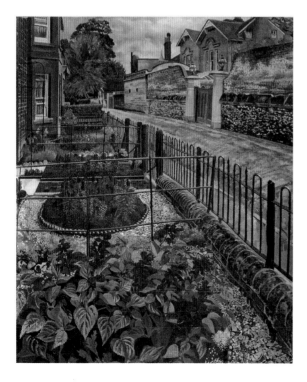

39 *Gardens in the Pound, Cookham* 1936
Oil on canvas
91.5 × 76.2
(36 × 30)
Leeds Museums and Galleries (City Art Gallery)

40 Spencer's
marriage to Patricia
Preece, 29 May 1937
From left to right:
Dorothy Hepworth,
Patricia Preece,
Stanley Spencer, Jas
Wood, Courtesy
Hepworth Archive

Ives painting landscapes in the rain, after which time he, Patricia and Dorothy returned to Cookham to their respective houses.

Spencer's plan to have two women was very likely hatched with Patricia's blessing, despite her protestations. She benefited financially from marriage to Spencer, but she did not want to perform conjugal duties – that could be left to Hilda. Spencer's act of adultery with Hilda immediately after their wedding, encouraged by Patricia, absolved her of legal blame for the failure of her marriage, should it come to that. In any case, she did not have anything against Hilda; she merely wanted to provide for herself and for Dorothy. Spencer clearly did not want to give up Hilda, and she, Patricia, did not want to give up Dorothy, who clearly adored her. Spencer had the idea that unusual *ménages* were *de rigueur* in some bohemian circles, and he was sure that in some more enlightened cultures polygamy was approved of. 'The law does not allow me to have two wives,' he wrote in the autumn of 1936, in a letter to Hilda that was never sent. 'Yet I must and will have two. My development (as an artist) depends on my having both you and Patricia.'[19] Marriage, after all, was far more than a legal matter; it was 'the chiefest unity', a profound spiritual and physical bond – why should he not be married to more than one woman, if that was what he needed? Why should he not have as many wives as he wanted?

In the midst of this fiasco, in a prolific stream of paintings, Spencer continued to explore his obsession with sexual relations. In 1937–8 he was at work on a series of paintings he called the *Beatitudes of Love*. Each of these depicted a couple, and each explored a different facet of a sexual relationship, or, as Gilbert Spencer put it, 'the triumph of love over every physical disadvantage'.[20] They were given titles such as *Nearness*, *Knowing*, *Seeing*, *Contemplation*, *Consciousness*, *Worship*, and *Age*, and were supplemented by commentaries by Spencer. *Desire* (or *Passion*) (1937–8) depicts a couple

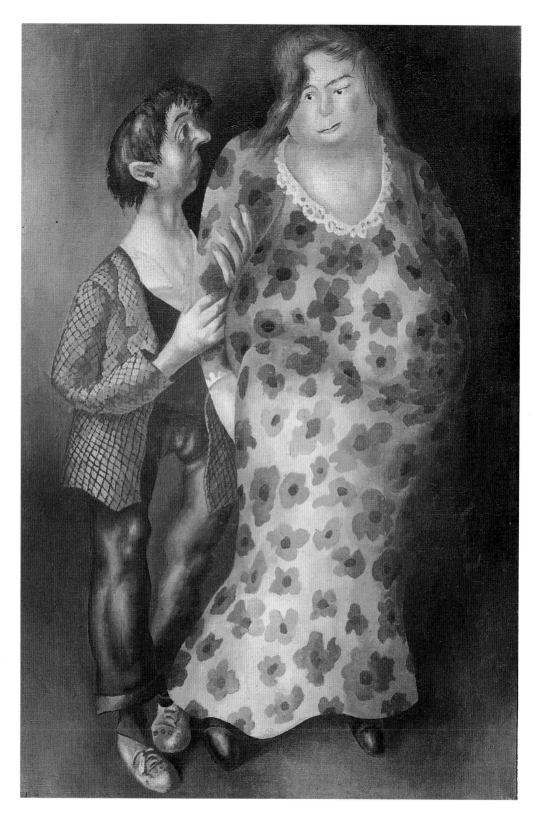

41 *Desire* (or
Passion) 1937–8
Oil on canvas
76 × 50 (30 × 19¾)
Private Collector c/o
Alex Reid and
Lefevre

described by the artist as 'an Office Boy and his wife', but which bears a strong
– if grotesquely distorted – resemblance to Spencer and Patricia (fig.41). 'I love
the way he holds her,' wrote Spencer. 'He does not care how he holds her or
where or what part of her so long as he has got hold of her.'[21] The figures in
the *Beatitudes* are supposed to be gripped with sexual desire, their bodies com-
municating wordlessly. Yet Spencer's often lengthy commentaries supply
what the pictures do not directly show. The images were the starting-point of
the artist's fantasies, and the occasion for his sexual imaginings. 'She has been
felt and fingered by him for fifty years,' wrote Spencer excitedly in a commen-
tary on *Age*. 'He has emptied himself into her about eighteen thousand times
...' 'Some hours later when they were going to bed she said to him you know I
feel wonderful with your stuff inside me. I think the idea of taking the sacra-
ment must have come from this really. I can feel the virtue of you in me ...'[22]

Spencer could not see why any subject should remain out of bounds to him
as a painter, but the law – as he regretfully recognised – saw it differently. In
private drawings, he could create images that would not have been acceptable
in a publicly displayed painting; but even such drawings were not safe. In 1950
Sir Alfred Munnings, erstwhile President of the Royal Academy, threatened
Spencer with prosecution for obscenity for some private drawings that had
somehow come into his possession. The prosecution was dropped, but Spencer
was left shaken by the allegations. He seems to have destroyed a number of
works (of which *Age* was probably one) wrapped up the *Leg of Mutton Nude*
and kept it under his bed, and resorted even more to 'symbols' for the sexual
act in his final, unfinished celebration of conjugal love, *The Apotheosis of Hilda*
(1959).

In October 1938 a distressed and scruffy Spencer turned up at the North
London home of his friends John and Elizabeth Rothenstein. Having signed
over Lindworth to his wife, he had now apparently been evicted from the
premises to make way for a new tenant. His marriage to Patricia had failed,
and he had let down Hilda and the children. He felt he had lost his vision, and
talked about suing the War Office for compensation for what he had suffered
during the war twenty years earlier. Financially, too, he was in a terrible mess.
Hounded by the Inland Revenue, and pursued by Hilda's solicitors for mainte-
nance payments, he also owed money to his own solicitor. He seemed confused
about how this situation had arisen. 'He was profoundly disturbed in mind,'
according to Elizabeth, and talked incessantly to anyone who would listen
about his problems – financial, artistic, sexual, marital.[23] By the end of the
year Spencer had been baled out by his dealer, Dudley Tooth, who took over his
financial affairs. Another friend, Malcolm MacDonald, rented a room for him
in Adelaide Road in Swiss Cottage, near the Rothensteins' home. It was here
that Spencer embarked on a series of biblical paintings, *Christ in the Wilder-
ness*, in a deliberate attempt to regain something of the religious feeling that
his lusts had tempted him away from. 'I was, as it were, in a wilderness,' he
wrote.[24] The wilderness was productive, even enjoyable: relishing his new-
found solitude, Spencer completed nine out of an imagined forty images – one
for each day of Lent – intended for the ceiling of Cookham church (fig.42).

Spencer was by now convinced that divorcing Hilda had been a mistake,

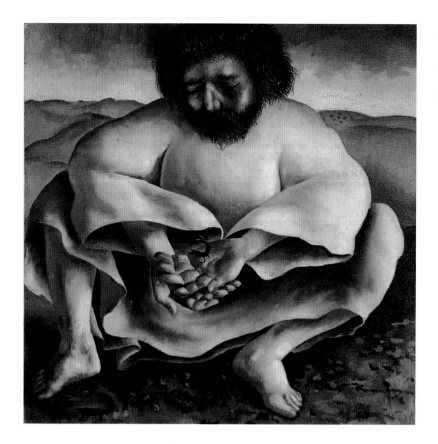

42 *Christ in the
Wilderness: The
Scorpion* 1939
Oil on canvas
56 × 56 (22 × 22)
Collection, Art
Gallery of Western
Australia

and he never gave up the idea of a reunion with her, although he still worried about their incompatibility, and he often wondered whether he wasn't happier by himself. Throughout 1941 and 1942 he wrote to her very often, sometimes every day. He still *felt* married to her, he insisted, despite everything. In January 1942 he suggested to her that they remarry. Hilda refused. 'You are too much of an artist to have satisfactory relations with any woman,' she told him. 'That is the price you have to pay for your genius.'[25] By now Hilda was in her own wilderness. Suffering from delusions and mental distress, in June she was admitted to Banstead Mental Hospital in Surrey, where she remained for nine months. Spencer visited her often in hospital, where they would read out each other's letters, an activity in which he saw great significance, and which he recorded in a drawing that was very precious to him. He still hoped for remarriage. But in 1947 Hilda was diagnosed with breast cancer, and she died in November 1950.

After the failure of his second marriage Spencer may have had other lovers, but his bond with Hilda was never severed. In 1945 he was still entertaining the idea of having more than one relationship: in a letter to his lover Charlotte Murray he asked whether his relationship with her would change if he were to remarry Hilda. Hilda, it seems, was vital to his art, his imagination and his mental equilibrium. He needed her most of all, perhaps, as the recipient of his letters, the invisible audience for his thoughts, his love-object, even after she

was dead. She became, in his imagination, the very principle of love, and an inseparable part of him, despite everything. 'I *can* only feel that *one*ness that I love, with you,' he told her in 1943. 'I could identify myself with you utterly so that I felt like a single being that was me and you. Also you are the only being I can write to or want to. It is a wonderful thing to write and not have to be careful what I say ... Nothing ever compensated me for the loss of you.'[26]

In the letters that he wrote to Hilda – many of them intended to form part of his autobiography – and in his art, Spencer relived the early years of their marriage over and over again. Nostalgia for his early married life at Burghclere had in fact begun as early as 1935–6, in the *Domestic Scenes*, painted around the time that a distressed Hilda was preparing to file for divorce. In these pictures, Hilda and Stanley, in a blessed state of matrimony, go about their daily business: they rummage in a chest of drawers; she helps him with his collar (see figs.43, 16). In the so-called *Scrapbook* drawings, begun around 1939, and worked on through the 1940s, Spencer again recalled incidents

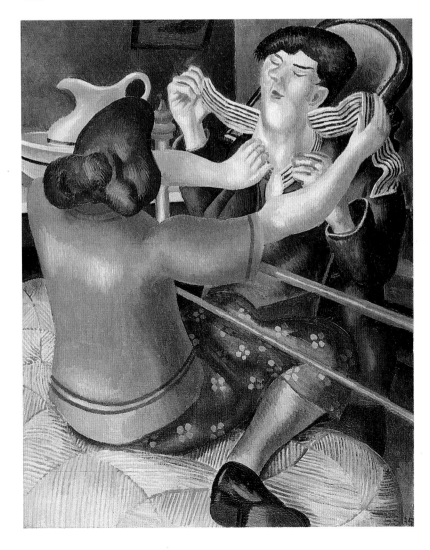

43 *Taking off Collar* (or *Buttoning the Collar*) 1935
Oil on canvas
50 × 40 (19½ × 16)
Private Collection

from his life with Hilda, some of which were made into paintings in the 1950s. In 1955, five years after Hilda's death, Spencer finished *Love on The Moor*, which he had started in 1937. The final painting gives a central role to Hilda, who appears as Venus on a pedestal in the middle of Cookham Moor, with Spencer wrapped around her legs in adoring supplication.

Painting a thing, for Spencer, was a way of making love to it, just as writing to Hilda was a way of making love to her – without risking unpleasant rows and disagreements. Spencer's paintings, like his writings, were also a way of organising his experience to his own satisfaction. 'My doing pictures seems to be my way of having my own way,' he wrote. 'Seem I to be outcast from these various lovely atmospheres well then I will by the grace of God create those wanted places and go into occupation at once. It is ones birth right.'[27] Painting was a way of creating another world, a world in which people make love freely in public, where there is no domestic strife; a place where the removal of a collar is charged with an eternal significance that is both sexual and religious, a place where everybody understands each other, and everybody is 'saying yes'. Hilda could be resurrected from the dead to preside for ever over Cookham as the goddess of love. And, on the Last Day, as in *Hilda Welcomed* (1953), she would be embraced by the other women in his life, and all – including Spencer himself – would be redeemed (fig.44).

44 *Me and Hilda*, drawing for *Hilda Welcomed* 1953
Pencil on paper
40.5 × 28 (16 × 11)
Private Collection

4

CHAPELS OF WAR AND PEACE

Throughout his life, Spencer made frequent lists of his paintings, obsessively classifying them according to different themes or sequences. When he devised an image, too, unless it was a landscape or portrait 'potboiler', inevitably it would take its place in his vision of a broader scheme, a whole series of related images. According to his daughter Shirin, 'he would have a huge idea, like a book, and then the chapters would be the different drawings and in the chapter would be all these little notions which, once he had done them he didn't change or move around'.[1] The grandest of these 'huge ideas' was the Church-House project, which Spencer was working on until he died, despite the fact that no patron came forward to finance it, thus forcing him to sell off its constituent paintings individually. The Church-House was conceived as a counterpart to the Sandham Memorial Chapel in Burghclere, which occupied Spencer from 1927 to 1932. At Burghclere, Spencer succeeded in bringing to completion an entire cycle of images documenting his experiences – real and imagined – during active service in the First World War. The Church-House, in contrast, was to celebrate the joys of peace, and would include under its imagined roof nearly all of Spencer's paintings, past, present and future. Both the Church-House and the Sandham Memorial Chapel were projects of personal redemption. Here Spencer's memories, experiences and desires were to materialise in painted form, orchestrated into fresco-like series reminiscent of the Trecento and Quattrocento Italian masters he had admired for so long. Instead of telling the life of Christ, however, these schemes narrated the life, loves and memories of the artist himself.

The Sandham Memorial Chapel

In 1915 Spencer enlisted in the Royal Army Medical Corps. For a year he worked as an orderly at the Beaufort War Hospital, formerly a lunatic asylum, on the outskirts of Bristol. Having volunteered for the Field Ambulances, in August 1916 he was posted to Macedonia, and a year later he became an infantryman in the 7th Battalion of the Royal Berkshires in the Balkans, returning to Cookham at the end of 1918. Throughout this time, Spencer did no painting and little drawing, although he took with him to Macedonia a pile of his beloved Gowans and Grey editions of what he called ''igh art', including the works of Fra Angelico, Carpaccio, Giorgione, Gozzoli and Raphael.[2] On his return to Britain Spencer completed a painting commissioned by the Ministry of Information, based on his experiences with the Field Ambulances, entitled *Travoys with Wounded Soldiers Arriving at a Dressing Station at Smol, Macedonia* (1919) (fig.45). Then he went back to his 'Cookham' work, claiming his

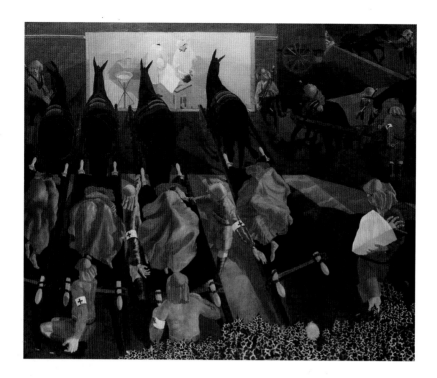

'Balkanish feeling' was lost. But the images of war, so different from the benign images from his childhood, had powerfully imprinted themselves onto the artist's imagination, and were bound to resurface. In 1923 Spencer planned a major series of works based on his memories of active service, while staying with Henry Lamb in Poole. When Lamb's friends Louis and Mary Behrend saw these drawings, they commissioned Spencer to paint a memorial to Mary's brother, Lieutenant Henry Willoughby Sandham, who died after becoming ill during active service. The Behrends proved to be uncommonly generous patrons. Not only did they foot the bill for a chapel to be built to Spencer's specifications (see fig.46), they paid the rent on his London studio whilst he completed *The Resurrection, Cookham*, built him and Hilda a house to live in near the chapel, and left him to complete his work undisturbed.

One of the books Spencer had with him in Macedonia was Ruskin's book on Giotto's frescoes at the Arena Chapel in Padua, a gift from his Slade friends Gwen and Jacques Raverat in 1911. Spencer loved this book, which, alongside his Gowans and Grey *Giotto*, inspired a number of his works, including *Joachim Among the Shepherds* (1913) (see figs.12, 23). He loved Ruskin's description of Giotto as a labourer, a travelling decorator of walls, and he was exhilarated by the idea of an entire cycle of images, a public work of art, housed in a single purpose-built structure. 'What Ho, Giotto!' exclaimed Spencer, reportedly, when he received the Behrends' commission. The artistic freedom and financial support offered by the Behrends allowed Spencer not only to think on a large scale, but also to see his ideas bear fruit. The result is both an unusual and extremely moving war memorial, and a spectacular work of art (fig.47). Both side walls of the chapel are divided into four arched panels, each accom-

panied by a predella image. Above the arched panels, on each side, is a large painting covering the whole wall. All of the panels depict remembered scenes from Beaufort Hospital, Macedonia, and Tweseldown Camp near Aldershot where Spencer spent time before going to Salonika with the Field Ambulances. Unlike many war memorials, these images do not commemorate the heroism and brave sacrifice of soldiers in action. Instead they focus on the domestic lives of soldiers and civilians, all the unremarkable everyday facts of life in an army hospital or camp. At the far end of the chapel, in the place occupied by *The Last Judgement* in Giotto's Arena Chapel, the epic *Resurrection of the Soldiers* covers the wall behind the altar (fig.48). The scene is imagined as

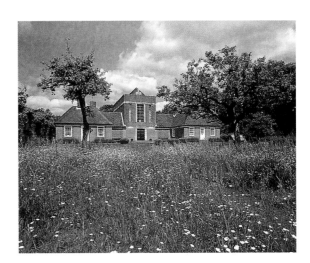

46 Sandham Memorial Chapel (National Trust), Burghclere

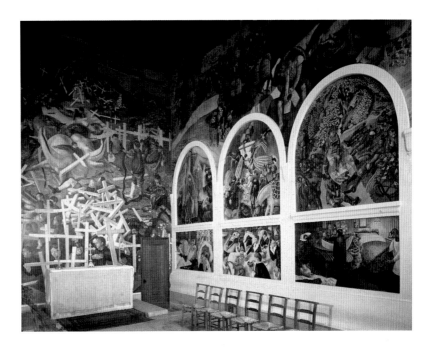

47 Sandham Memorial Chapel (National Trust), Burghclere, view of interior

taking place just outside the walled village of Kalinova, in Macedonia. Here, in a variation on the theme of *The Resurrection, Cookham,* soldiers rise out of their graves and hand in their standard-issue crosses to Christ, who sits towards the top of the image. The handing-in of army equipment at the Armistice is here transposed into a heavenly register, where belongings are returned as soldiers rise from the dead. One man, for example, takes out a red book from his pocket, identified by Spencer as 'a little red leather covered Bible' he was given by 'sister flo' that he had lost. 'Being the resurrection,' he writes, matter-of-factly, 'I find it.'[3]

The visitor to the Burghclere chapel is therefore presented with a visual experience with a double focus. First there is the impression of the scheme as a whole, with its palette of rich, earthy colours, and its narrative sequences, climaxing in the Resurrection image. Then there are the individual details, touching in their human simplicity. In the hospital wards someone tucks his bed-sheet in, a patient puts some jam on his bread at tea-time, lockers and floors are scrubbed. In the Macedonian scenes, bacon rashers are cooked and distributed, soldiers pick bilberries and wash their clothes in a river. Spencer painted these incidents in all their remembered sensuous particularity: the exact way the sun shone down the hospital corridor when he was scrubbing the floor, the patterns of the ward wallpaper, the puttees worn by the soldiers around their shins.

The chapel at Burghclere gave a home – literally – to Spencer's wartime memories, and looking at these pictures of cosy camaraderie, one might think that his experience of the war had been similarly untroubled. A closer look, however, both at these images and at Spencer's writings tells another story. For although death, and the horror of war, does not put in a direct appearance in the Burghclere panels, it is conspicuous by its very absence. Death, in a sense, is the absent referent of this cycle of images. For, as the final Resurrection scene makes plain, it is death that awaits these soldiers as they fry their bacon, and fix their tents; and it is death that lingers in the wings of the Beaufort hospital, while the orderlies and nurses try to ward it off as they bathe their patients, paint them with iodine, and do their laundry. And after all, the chapel itself was designed to memorialise the death of a soldier who, like Spencer, had served in Macedonia.

As a young orderly at the hospital, and as a recruit in the Royal Berkshires, Spencer was only too aware of the dehumanising effects of war, and the omnipresence of death. 'I could not help feeling what a damnable world this was when I was having my tea yesterday,' he wrote to Henry Lamb in February 1916, after a friend had died at Beaufort Hospital.[4] As he scrubbed floors, washed patients, made beds and emptied slops, Stanley was determined to maintain his identity through creative thought. Inspired by a passage in St Augustine's *Confessions,* he started to think of his menial work as a kind of service to God. Later, in Macedonia, he tried the same technique of seeing things differently to make his experiences bearable, no matter how bad. 'Every incinerator was an Altar,' he wrote.[5] Positive thinking, however, could not save lives. Spencer, like so many others, lost comrades, friends and family in the war. Waiting to attack with the Royal Berkshires in the Vardar valley, one of

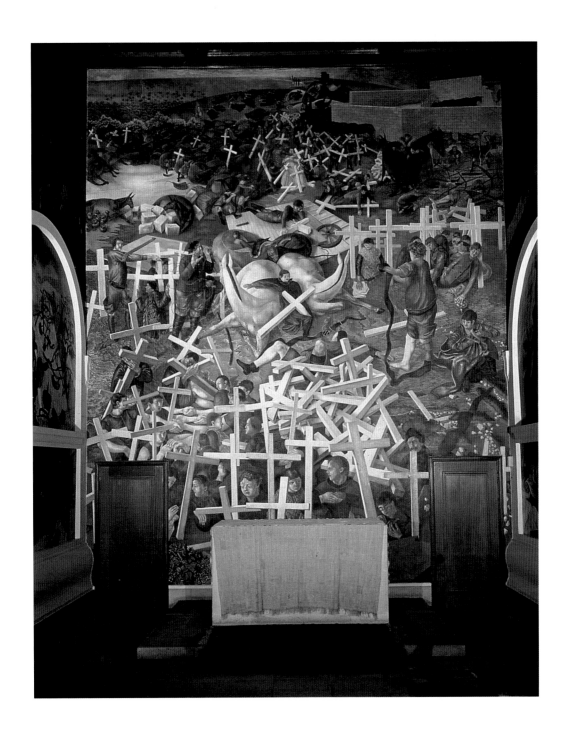

48 *The Resurrection of the Soldiers* 1928–9
Oil on canvas, glued to a wall lining of asbestos cloth, East wall
Sandham Memorial Chapel (National Trust), Burghclere

his fellow infantrymen stabbed himself with his own bayonet. Stanley was himself the victim of bullying which at one point, according to him, nearly resulted in his own assassination. When he got home from Europe he discovered his beloved brother Sydney had been killed in action. If it had not been for these appalling experiences, perhaps Spencer would never have done his Resurrection pictures – they are, in a sense, the triumph of hope over experience; painting as an act of faith. 'I had buried so many people and saw so many dead bodies that I felt that death could not be the end of everything,' he told a reporter from the *Birmingham Post* when *The Resurrection, Cookham* was first exhibited in 1927.[6]

The side-panels of the Burghclere memorial show Spencer's determination to find a heaven in the hell of war, focusing on all the homely details of life in hospital or at camp. And if death awaits these soldiers at the front, or in hospital, so too does redemption; a fact that Spencer found various formal means to suggest. Despite their meticulous realism, these pictures are full of intimations of immortality and transcendent new life. In *Patient Suffering from Frostbite*, for example, the pails carried by the ward orderly miraculously transform him into a ministering angel, as they take on the appearance of wings (fig.49). In *Reveille*, the mosquito nets are depicted with scrupulous verisimilitude (fig.50). Yet they are not just mosquito nets; they also recall death-shrouds, angels' wings and the pupae of winged insects. The soldiers at the right of this picture, we are told, are announcing the Armistice; those within the illuminated nets will emerge to a new world of peace, like butterflies coming out of their chrysalises or bodies resurrected from the dead. This is the painter's trick that Spencer used in *Christ Carrying the Cross* to show the interpenetration of heaven and earth, where ordinary objects combine and momentarily take on a numinous appearance, without losing anything of their ordinariness. This is not simply symbolism, because the utilitarian identity of these objects remains an important part of their meaning. In the Burghclere panels, this device was partly a way of blessing the various mundane activities Spencer took part in during the war: a kind of transubstantiation of the menial. But these pails and mosquito-nets also precipitate a revelation in the midst of an otherwise mundane reality, an uncanny prefiguration of the Resurrection depicted in the altar-piece. They are the visual expression of Spencer's conviction that 'every Army incident was a coin, the obverse of which was presented to me and on the unseen face of which was the Resurrection.'[7]

Spencer experienced war as a stripping of identity that threatened to blast to pieces his precious sense of self, severing him from his home, his family, and his vision. The commission to paint the Sandham Memorial Chapel gave him the opportunity to redeem his traumatic wartime experiences by translating them into art. 'It has been my way to make things as far as I am able to – fit me,' he wrote, 'so I did the Burghclere Memorial that operation redeemed my experience from what it was; namely something alien to me. By this means I recover my lost self.'[8]

49 *Patient Suffering from Frostbite* 1932
Oil on canvas, glued to a wall lining of asbestos cloth
105.5 × 185.5
(41½ × 73)
Sandham Memorial Chapel (National Trust), Burghclere

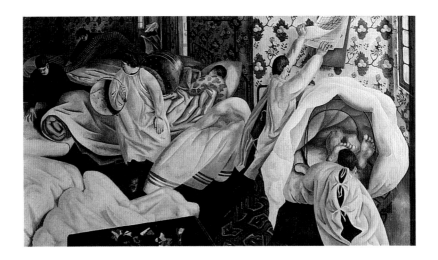

50 *Reveille* 1929
Oil on canvas, glued to a wall lining of asbestos cloth
213.5 × 185.5
(84 × 73)
Sandham Memorial Chapel (National Trust), Burghclere

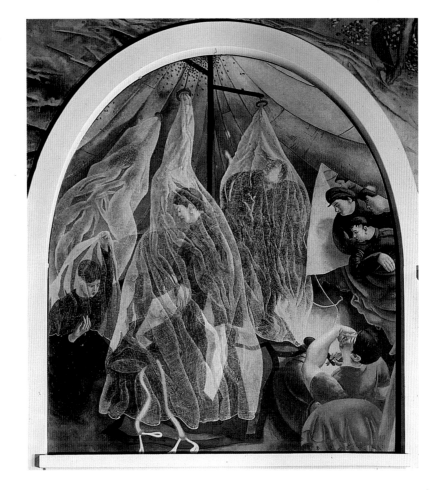

Church-House

While he was at work at Burghclere, Spencer began to nurture the idea of a new project on an even bigger scale. This scheme would fuse all his loves, in a painted autobiography that was also a celebration of Cookham in peacetime and a reworking of elements from the life of Christ. Within the walls of this building that was to be half home, half chapel, the artist could bring together his secular and his religious concerns, removing the false boundaries that kept such things apart. The Church-House, as its name suggests, was to be a building that was both sacred and profane, public and private, a consecrated home and a temple to domesticity and conjugal love. Its groundplan was designed to correspond to the various parts of Cookham, translating Spencer's home village into sacred architecture. The nave would be Cookham High Street, and the transepts the roads that run perpendicular to it, Sutton Road and the road to Bourne End. One aisle would correspond to the river, whilst the other would be School Lane. The paintings that were to hang on the walls would themselves correspond, broadly, to the different parts or 'atmospheres' of Cookham's streets and river. Submerged within these sequences of images would be three narrative cycles: *The Marriage at Cana*, *The Pentecost* and the *Baptism of Christ*. Thus, for example, *Sarah Tubb and the Heavenly Visitors* (1933) and *Villagers and Saints* (1933) were 'street scenes' imagined in the nave of the Church-House, and part of the *Pentecost* scheme – a series of images in which the apostles come to Cookham and walk around blessing its inhabitants.

From the early 1930s until his death, the Church-House idea grew in Spencer's imagination, becoming ever more ambitious. At first, he imagined a chapel and two adjoining houses, with smaller chapels dotted throughout the grounds. Gradually, the project evolved until it was a single building. As Spencer's interest in sex gained momentum in the mid-1930s, the Church-House increasingly became a temple to sexual love, a home for all of his paintings of love in action. Inspired in part by the erotic sculptures at the temples at Khajuraho in India, which he had seen in photographs, the Church-House was to be a self-justifying declaration of a personal faith that saw sexual union as sacred. *A Village in Heaven* and *Love Among the Nations* found their place here; so did *Adoration of Girls* (1937) and *Adoration of Old Men* (1937) where young women sexually proposition elderly men, *en masse*, in Cookham. The *Beatitudes* were to be housed each in its own cubicle off the church aisles, where visitors could meditate on the sacred nature of sexual desire and marriage. Each of the women in his life was to have her own memorial chapel, each with its own altar-piece, and each decorated with portraits, imagined scenes and remembered incidents associated with its dedicated household goddess. Eventually five such chapels were planned: one for each of Spencer's wives (see fig.51), one each for his lovers, Daphne Charlton and Charlotte Murray, and one for Elsie Munday, the Spencers' maid, who in Spencer's imagination was the archetype of working-class good sense and cheerfulness.

The Church-House never became a reality. Nor did Spencer work on it exclusively. The early 1940s, for example, were dominated by a series of paint-

ings of Glasgow shipyards commissioned by the War Artists Advisory Committee. Spencer responded very positively to the atmosphere of Lithgow's shipyard in Port Glasgow, which he found 'homely'. The various labours of welders, burners, riveters and riggers were choreographed by Spencer into a sequence of images in which the mundane tasks of the factory-worker take on an epic, almost religious aspect (fig.52). Yet as an imaginary structure the Church-House determined nearly all Spencer's uncommissioned imaginative works in the last twenty-five years of his life, possibly even including the ambitious Glasgow Resurrection series of the later 1940s. Even though individual works were sold separately, they all had their place in Spencer's imagined 'Church of Me' where, he insisted, they made sense as part of an organic whole. The *Domestic Scenes* of 1935–6, for example, were part of the *Marriage at Cana* series, as was *Bridesmaids at Cana*, painted around the same time, and *A Servant in the Kitchen Announcing the Miracle*, completed some eighteen years later (fig.15). Seen in the context of this series, the *Domestic Scenes* are not just Hilda and Stanley at home, they represent couples getting ready to go to the wedding feast or returning home from it. A theme like the New Testament story of the Marriage at Cana, in Spencer's hands, was flexible enough to include many of his favourite things – conjugal love, domesticity, Cookham, the Bible – and he returned to it after Hilda died. In *The Marriage at Cana: Bride and Bridegroom* (1953), a painting intended for the elaborate Hilda chapel (the 'you-me room'), Spencer tenderly pulls out a chair for Hilda, his new bride, in an image that is both a memory of their wedding-day, and a painted substitute for a remarriage that never took place (fig.53).

The whole of the Church-House was united by the theme of the 'Last Day', in which no one and nothing is discarded, but all are redeemed and blessed. 'All things are redeemable,' he wrote, 'and I paint them in their redeemed state.'[9] This is the significance, for Spencer, of the mouldy cabbage and the old teapot that the children retrieve from the dustbin in *The Dustman* or *The Lovers* (fig.28). It also partly explains the grotesque appearance of the couples in the

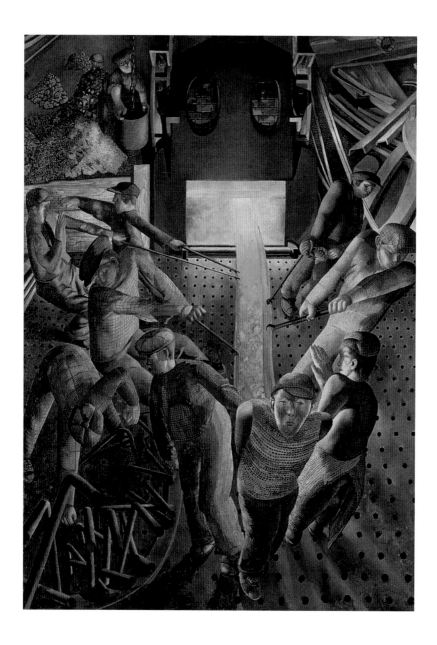

Beatitudes which contemporary viewers found so repellent. 'Oh, Stanley, are people really like that?' Eddie Marsh reportedly asked.[10] Disingenuously, perhaps, Spencer denied the charge of ugliness and wilful distortion. Yet the fact that these figures are perceived as grotesque nevertheless demonstrates his belief in the transforming power of sexual love. Just as the Last Day restores those bits of household detritus that had been thrown away, the love and desire felt by these couples, one for the other, redeems them despite their 'degenerate' appearance. After all, the title *Beatitudes* refers to Christ's preaching that the meek, the pure in heart and the persecuted shall receive the blessings of heaven. 'I am always taking the stone that was rejected and making it

the cornerstone in some painting of mine,' wrote Spencer, characteristically mimicking biblical language.[11] The results have often led critics to suspect Spencer of an unhealthy predilection for deformed bodies and the contents of rubbish bins. According to Spencer this was because his paintings were never seen in the architectural context for which they had been designed. Had the Church-House been built, it would have blessed everything within its walls: all its images of lust, love and spiritual ecstasy; all Spencer's sexual liaisons, real and imaginary; all of his experiences, good and bad; all of the places he loved. Spencer believed that love 'establishes once and for all time the final and perfect identity of every created thing.'[12] The Church-House would provide just this framework of love; everything within its walls would be seen in its true and heavenly light; without it, alas, his grotesque figures with their awkward gestures risked the charges of distortion and 'indecency'.

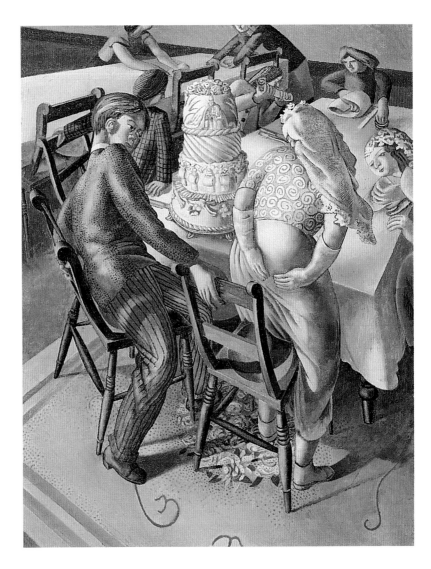

Spencer's vision and the redemption of memory

Both the Sandham Memorial Chapel and the Church-House took redemption as their theme; in their execution, both projects also involved the redemption of Spencer's memory. At Burghclere, ten years after the war, Spencer translated his memories of service into paint. The Church-House, too, was conceived as a memorial to the artist's past lives and loves, stretching back to his childhood. Many of the paintings destined for the Hilda, Patricia, Elsie and Daphne chapels, for example, were to be based on his *Scrapbook* drawings, which Spencer worked on throughout the 1940s. These drawings largely involve scenes remembered from the artist's past. One is a memory of Elsie bringing in the washing (fig.54). One depicts an angular Patricia dancing to a gramophone record, while in another image Hilda dries herself at the towel rail in the bathroom at Burghclere (fig.55). Recording scenes such as these, ten to twenty years after they took place, was a powerful impetus behind Spencer's work in the 1940s and 1950s. In a sense, this salvaging of memory was itself a kind of resurrection. Describing 'the Painter of Modern Life' in 1863, the poet Charles Baudelaire spoke of 'an intense effort of memory that evokes and calls back to life – a memory that says to everything, "Arise, Lazarus."'[13] Like Baudelaire, Spencer knew that the exercise of memory could almost bring a lost moment back into existence.

Many of Spencer's friends and critics have remarked on his powers of memory. He could remember whole passages of music as well as images glimpsed, perhaps only for a moment, long ago in his childhood. Spencer's prodigious memory was connected, no doubt, to his extraordinary and much-documented perceptual appetite. 'He had one tremendous ability,' wrote Vaudrey Mercer, his doctor, 'he could see.'[14] More than this, though, he had the capacity to absorb and internalise certain images and sensual stimuli: the texture of a tweed jacket, the gesture of a woman smoothing down her skirt, the form of a hospital bath. These remembered images and forms might come out later – sometimes many years later – in a painting. The artist John Bratby remembers Spencer in 1957 excitedly describing, and then drawing

> a small visual incident, seen many years before, that he had always
> wanted to make the subject of a painting, but had never actually done
> so. He had seen a little girl lose her playing ball under a fence made of
> wire netting, and her bent figure trying to retrieve the ball at the
> expanse of netting was an image that had stayed with him over the
> years.[15]

It was not simply that Spencer could reproduce the *appearance* of things in a straightforward act of mimesis, although – as his landscape and portrait paintings demonstrate – he certainly could. It did not only involve the sense of sight. It was more that he could absorb the unique physiognomy of an object, a gesture, or a place, and later resurrect this physiognomy in an image. 'Things have an internal equivalent in me,' wrote the philosopher Maurice Merleau-Ponty, describing a painter's perception of the world, 'they arouse in me a carnal formula of their presence.'[16] A little girl reaching for a ball; the

54 *Taking in
Washing, Elsie*
1943–4
Pencil on paper
40.5 × 28 (16 × 11)
Thomas H. Gibson

55 *Hilda Drying
Herself*
Pencil on paper
40.5 × 28 (16 × 11)
Private Collection

shape and texture of a towel on a rail; the posture of his wife as she dried herself – these things aroused in Spencer an almost mystical 'carnal formula of their presence'. Later such a formula would surface and become externalised in Spencer's art, as an icon dense with personal meaning, immortalising his memory, destined for the sacred architecture of the Church-House.

It was these remembered gestures, objects and spaces that were the building blocks of Spencer's art rather than the medium of paint. In this sense, Spencer was more a picture-maker than a painter. His earlier works were the most painterly: the studies that exist for *Mending Cowls* and *Christ Carrying the Cross* show him experimenting with broad brushstrokes of colour and washes of paint. Yet Spencer's working practice became increasingly formulaic. The initial drawing was always the most important part. Here he had the excitement of seeing an idea or memory find form. Once the drawing was finished, squared-up and transferred to canvas, Spencer saw the painting of many of his later works as a tedious matter, referred to by him as 'knitting'; simply colouring-in, which he often began in one corner of the picture, mechanically proceeding to cover the entire surface of canvas with a thin layer of colour. Spencer's working habits at their most methodical can be seen clearly in one of his last and unfinished works, *Christ Preaching at Cookham Regatta*, the huge painting that was probably destined to be the altar-piece to the river-aisle of his Church-House (fig.56). Increasingly Spencer's pleasure was in perception, in memorialisation, and in the choreography of form; he took very little pleasure in painting itself, or in colour. And perhaps it is because his works are *pictures* rather than paintings that his works lose so little in reproductions.

Spencer's works of the 1940s and 1950s have been criticised for both their form and technique. Writing in 1950, the artist, writer and critic Wyndham Lewis explained why Spencer, as well as being unpopular at the Royal Academy for his 'aggressively corpulent' women and 'lower-middle-class' subject matter, 'is not the artist's cup of tea either': 'Spencer, it is felt, is careless of paint. His painting is the negation of quality. It is quantitative. He is endlessly repetitive. One feels he could turn out a thousand figures as easily as a hundred, it would take him ten times as long that is all.'[17] Certainly the *Glasgow Resurrection* series, *Christ Preaching at Cookham Regatta* and the unfinished *Apotheosis of Hilda* seem to be exercises in visual excess, canvases brimming with narrative detail. These pictures seem to conform to Baudelaire's warning that 'an artist with a perfect sense of form but one accustomed to relying above all on his memory and his imagination will find himself at the mercy of a riot of details all clamouring for justice with the fury of a mob in love with absolute equality'.[18] These were dense pictures to be 'read', almost like the Victorian crowd paintings of W.P. Frith, although in Spencer's works the meanings were private and esoteric. In a painting like *Christ Preaching at Cookham Regatta*, each tiny element told a story to its creator; each figure, every gesture was a repository of memory and significance. The man in the foreground, for example, is Mr Turk, who owned the boatyard in the Cookham of Spencer's youth. Spencer liked to dwell on these small incidents in his paintings, sometimes holding up a frame to isolate them from their surroundings. The

Apotheosis of Hilda, although unfinished, was also a composite image of innumerable events and tableaux, the meanings of which Spencer discussed at length in his writings. The abundance of incident in these pictures is perhaps due to the hypertrophy of Spencer's memorialising tendency in his last years. But it may also have something to do with the fact that the Church-House never materialised. If his memories could not find their place in a series, under one roof, they would increasingly be crowded into single paintings.

As John Bratby comments, 'Spencer got excited about things. That is the salient fact.'[19] Spencer's excitement was an excitement of the senses, a physical and spiritual *experience*. As such it was essentially irreducible to either verbal or visual language. The drawings and paintings that Spencer left behind are the records of his attempts to communicate his perceptual experience, using all the pictorial devices at his disposal. As early as 1918, Spencer told his friend Desmond Chute that 'my capacity to draw & paint has got *nothing* to do with my vision, it's just a meaningless stupid habit'.[20] Sometimes it seems as though Spencer possessed an extra sense, as though he had access to a secret language of objects, an arcane music of tea-urns, bed-pans and railings. Certainly things and places seemed to him to possess a double identity, corresponding both to this world and another, heavenly world. He worried when he could not access this other world, when he could not see things in their heavenly aspect. His paintings are an attempt to demonstrate the existence of the double life of things; in a sense they are lessons in seeing.

Spencer's need to see things in their extra-worldly aspect had a human cost, however. Often it was only after 'taking home' an event, as he liked to say,

56 *Christ Preaching at Cookham Regatta* (detail)
Unfinished, oil on canvas
205.7 × 535.9
(81 × 211)
Private Owner; On loan to the Stanley Spencer Gallery, Cookham

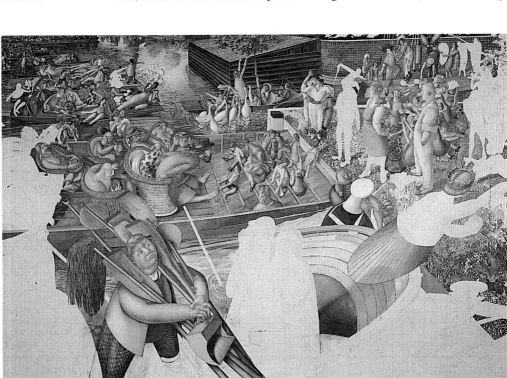

and re-experiencing it in memory, that he could see it in the way he wanted to. 'All things seemed to have to be memorials for me to love them,'[21] he wrote, and unfortunately this often applied to his relationships. Writing to Hilda in 1930, he told her

> This difficulty I seem to have of being able to retain as clear a vision of you when you are here or with me, that I can when you are away is rather, in fact exactly like the difficulty I have about painting from objects … With the object in front of me & with you with me I have to see a lot of things that I have not imaginatively comprehended & dont like.[22]

Spencer was arguably never happier than when he was on his own, reliving and redeeming his memories through writing and drawing. Reality was too often unpleasant; 'art is where I can find peace,' he said.[23] At times the price paid for this peace was heavy, particularly for those around him. Hilda, in particular, suffered for the role she was made to play (in life as well as in art) in Spencer's personal mythology as muse, Venus of the Moor, and fleshly goddess of hearth and home. This would matter less if Spencer had not nailed his artistic colours to the mast of love, if his work had been less biographical, or if so many subsequent critics had not repeated the artist's own most romantic interpretations of his actions and his works.

To claim Spencer simply as a visionary prophet of love, as some have, is to be forced to ignore or underplay aspects of his behaviour and his art that do not conform to this description, colluding with the artist's own anxieties about keeping and losing his vision. Seeing Spencer in this way implies that the human cost of his achievement was either irrelevant or worth paying; and it puritanically requires that his obsession with sex be understated, or excused as a brief and embarrassing lapse. But even if such a view were tenable, it risks divorcing Spencer from the very material contexts that fed him as an artist, the human muddle of bodged relationships, thwarted desires, egotism and social aspirations as well as marsh-meadow visions, religious feeling and domestic bliss. This was the man, after all, who told John Rothenstein: 'I'll have to turn up at the Gates of Heaven bringing all my faults … all my sins, sexual and all – I couldn't bear to leave anything behind.'[24] Spencer was an artist who – ever since his experiences in the First World War – ardently strove to recuperate lived reality in its most affirmative aspect, even when that reality was unpromising, sordid or abject. In this sense, his achievement can only be measured against his experiences, good and bad; to restore such things to a consideration of Spencer should therefore enrich rather than diminish an appreciation of his works.

Chronology

1891
Stanley Spencer born 30 June in Cookham-on-Thames, Berkshire

1907
Enrols at Maidenhead Technical Institute

1907–12
Attends Slade School of Fine Art, London

1912
John Donne Arriving in Heaven exhibited at Second Post-Impressionist Exhibition, London

1915–18
Enlists with Royal Army Medical Corps. Works as orderly at Beaufort War Hospital, near Bristol. Posted to Macedonia with Field Ambulances in August 1916. Becomes infantryman with Royal Berkshire's 7th Battalion in 1917, and returns to Cookham in December 1918

1919
Meets Hilda Carline

1920–2
Lives with Sir Henry and Lady Slesser at Bourne End. Stays at Durweston in Dorset with Henry Lamb. Spends time in Hampshire; moves to Hampstead in December 1922

1923
Stays with Henry Lamb at Poole in Dorset; returns to Hampstead

1925
Marries Hilda, 23 February. Shirin born in November

1927
First one-man show at Goupil Gallery, London. Moves to Burghclere, Hampshire in May to work on Sandham Memorial Chapel

1929
Meets Patricia Preece

1930
Unity born in May

1932
Moves from Burghclere to Lindworth, Cookham in January. Elected to Royal Academy. Dudley Tooth becomes his sole agent

1933
Visits Switzerland

1935
Resigns from Royal Academy after hanging committee rejects St Francis and the Birds and The Dustman or The Lovers

1937
Marries Patricia, 29 May.

1938
Stays with Rothensteins in London; moves to Adelaide Road, Swiss Cottage, and begins Christ in Wilderness series

1939
Stays with George and Daphne Charlton at White Hart Inn, Leonard Stanley, Gloucestershire

1940
Commissioned by War Artists Advisory Committee to paint shipyards. Visits Lithgow's shipyards in Port Glasgow

1945
Starts work on Port Glasgow Resurrection series (1945–50)

1946
Completes Shipbuilding on the Clyde series for War Artists Advisory Committee

1950 Reinstated at the Royal Academy. Hilda dies in November

1954
Visits China

1955
Retrospective exhibition at Tate Gallery, London

1959
Knighted. Dies 14 December at Canadian War Memorial Hospital, Cliveden, Berkshire

Notes

Tate Archive is abbreviated to TGA

Introduction

1 Fiona MacCarthy, *Stanley Spencer: An English Vision*, New Haven and London, 1997, p.7

2 Tate Gallery, Liverpool: *Stanley Spencer: A Sort of Heaven*, 1992, p.15

3 *Ibid.*, p.16

4 Martin Heidegger, 'Letter on Humanism' [1947], W McNeill, ed., *Pathmarks*, 1998, p.258

5 Keith Bell, *Stanley Spencer: A Complete Catalogue of the Paintings*, London, 1992, p.73

6 John Rothenstein, *Brave Day Hideous Night: Autobiography 1939–1965*, London, 1966, p.134

Chapter One: Home

1 Gilbert Spencer, *Stanley Spencer by his brother Gilbert*, London, 1961, p.28

2 *Ibid.*, pp.37–8

3 *Ibid.*, p.49

4 Elizabeth Rothenstein, *Stanley Spencer*, London, 1967, p.3

5 Royal Academy, London: *Stanley Spencer RA*, 1980, p.40

6 *loc. cit.*

7 Kenneth Pople, *Stanley Spencer: A Biography*, London, 1991, p.35

8 *Stanley Spencer RA*, p.39

9 Richard Carline, *Stanley Spencer at War*, London, 1978, p.33

10 Bell, p.272

11 *Ibid.*, p.250

12 *Ibid.*, p.15

13 *Ibid.*, pp.385, 19

14 TGA 733.3.85, p.208

15 *Stanley Spencer RA*, p.54

16 John Rothenstein, *Summer's Lease: Autobiography 1901–1938*, London, 1965, p.133

17 John Rothenstein (ed.), *Stanley Spencer the Man: Correspondence and Reminiscences*, London, 1979, p.20

18 *Ibid.*, p.150

19 See TGA 945.10

20 TGA 945.3

21 TGA 733.3.85, p.11

22 Stanley Spencer, 'Domestic Scenes', *The Saturday Book* 6, 1946, p.249

23 TGA 733.3.85, p.2

24 Gilbert Spencer, p.148

25 *Stanley Spencer the Man*, p.107

Chapter Two: Cookham

1 *Stanley Spencer the Man*, p.17

2 MacCarthy, p.13

3 *Stanley Spencer RA*, p.39

4 Gilbert Spencer, p.113

5 *Stanley Spencer: A Sort of Heaven*, p.17

6 *Stanley Spencer RA*, p.15

7 *Ibid.*, p.44

8 *Stanley Spencer: A Sort of Heaven*, p.17

9 Bell, p.389

10 Gilbert Spencer, p.79

11 Kenneth Pople, *Stanley Spencer: A Biography*, London, 1991, p.226

12 Carline, p.172

13 Maurice Collis, *Stanley Spencer*, London, 1962, p.29

14 TGA 882.5

15 Barbican Art Gallery, London: *Stanley Spencer: The Apotheosis of Love*, 1991, p.46

Chapter Three: Love, Sex and Marriage

1 Arts Council, London:

Stanley Spencer, 1891–1959, 1976, p.21

2 *loc. cit.*

3 Collis, p.83

4 *Stanley Spencer the Man*, p.32

5 *Ibid.*, p.53

6 *Ibid.*, p.38

7 *Ibid.*, p.34

8 *Apotheosis of Love*, p.61

9 *Stanley Spencer the Man*, p.48

10 *Ibid.*, p.53

11 *Ibid.*, p.54

12 MacCarthy, p.31

13 *Ibid.*, p.43

14 *Stanley Spencer: The Apotheosis of Love*, p.15

15 Bell, p.449

16 *Stanley Spencer: The Apotheosis of Love*, p.26

17 *Stanley Spencer the Man*, p.54

18 *Ibid.*, p.56

19 Collis, p.126

20 Gilbert Spencer, *Memoirs of a Painter*, London, 1974, p.184

21 Bell, p.460

22 *Stanley Spencer: The Apotheosis of Love* , p.56 (wrongly attributed to *Passion* or *Desire*)

23 *Stanley Spencer the Man*, p.103

24 *Stanley Spencer, 1891–1959*, p.22

25 Collis, p.174

26 *Stanley Spencer the Man*, p.72

27 TGA 733.3.85, p.179

Chapter Four: Chapels of War and Peace

1 Christie's, London: *Stanley Spencer Studio Sale, 5 November 1998*, 1998, p.8

2 TGA 945.35

3 TGA 733.3.85, p.153

4 TGA 945.31

5 TGA 733.3.85, p.140

6 Bell, p.76

7 TGA 733.3.85, p.150

8 *Stanley Spencer, 1891–1959*, p.21

9 Collis, p.163

10 *Ibid.*, p.144

11 *Stanley Spencer, 1891–1959*, p.23

12 Pople, p.344

13 Charles Baudelaire, *The Painter of Modern Life and Other Essays*, London, 1995, p.17

14 *Stanley Spencer the Man*, p.134

15 *Stanley Spencer the Man*, p.117

16 Maurice Merleau-Ponty, *The Primacy of Perception*, Chicago, 1964, p.164

17 Wyndham Lewis, 'Round the London Art Galleries', *The Listener* Vol.XLIII No.1112, 18 May 1950, 878–9

18 Baudelaire, p.16

19 John Bratby, *Stanley Spencer's 'Early Self-Portrait'*, London, 1969, p.10

20 *Stanley Spencer: The Apotheosis of Love*, p.96

21 Collis, p.94

22 *Stanley Spencer the Man*, p.37

23 *Stanley Spencer: The Apotheosis of Love*, p.98

24 John Rothenstein, *Summer's Lease: Autobiography 1901–1938*, London, 1965, p.233

Select Bibliography

Arts Council, *Stanley Spencer, 1891–1959*, London 1976

Bell, Keith, *Stanley Spencer: A Complete Catalogue of the Paintings*, London 1992

Carline, Richard, *Stanley Spencer at War*, London 1978

Collis, Maurice, *Stanley Spencer*, London 1962

Glew, Adrian (ed.), *Stanley Spencer: Letters and Writings*, London 2001

Leder, Carolyn, *Stanley Spencer: The Astor Collection*, London 1976

MacCarthy, Fiona, *Stanley Spencer: An English Vision*, New Haven and London 1997

Malvern, Sue, 'Memorizing the Great War: Stanley Spencer at Burghclere', *Art History* 23:2, June 2000, pp.182–204

Pople, Kenneth, *Stanley Spencer: A Biography*, London 1991

Robinson, Duncan, *Stanley Spencer*, Oxford 1990

Rothenstein, John (ed.), *Stanley Spencer the Man: Correspondence and Reminiscences*, London 1979

Spencer, Gilbert, *Stanley Spencer by his brother Gilbert*, London 1961

Stanley Spencer, exh. cat., Tate Britain, London 2001

Stanley Spencer: A Sort of Heaven, exh. cat., Tate Gallery, Liverpool, 1992

Stanley Spencer RA, exh. cat., Royal Academy of Arts, London 1980

Stanley Spencer: The Apotheosis of Love, exh. cat., Barbican Art Gallery, London 1991

Photographic Credits

Copyright Credits

Index

Angelico, Fra 18, 61
Augustine, Saint
 Confessions 64
autobiography, Spencer's 11, 12, 59

Bailey, Dorothy 17, 32
Balthus 10
Baudelaire, Charles
 'The Painter of Modern Life' 73, 75
Beaufort War Hospital, Bristol 61, 63, 64
Beckmann, Max 10
Behrend, Louis and Mary 62
Bell, Clive 17, 18
biblical works 9, 16, 17, 19–20, 32, 33–42, 68, 69
Blake, William 9
Bomberg, David 18
Braque, Georges 17
Bratby, John 73–4, 75
Bunyan, John
 The Pilgrim's Progress 17, 38, 39
Burghclere 27, 46–7, 59–60
Burghclere Chapel *see* Sandham Memorial Chapel

Carline family 46, 49
Carline, Hilda
 Church-House project 68, 69, 72; fig.51
 correspondence with Spencer 11–12, 48, 51, 55, 58–60, 76
 Elsie 47; fig.33
 marriage to Spencer 27, 41, 45, 46–9, 52–4, 57–60, 62, 76
 portraits by Spencer 46, 48, 57, 59–60; figs.32, 34, 43
Carpaccio 61
Carrington, Dora 18
Cervantes, Miguel de
 Don Quixote 17
Cézanne, Paul 17, 18
Chagall, Marc 10
Charlton, Daphne 68, 72
Church-House 9, 27, 42, 43–4, 61, 68–75
 sketch plan for Hilda Chapel fig.51
Chute, Desmond 32, 75
Cookham 7–8, 11, 15–17, 19–20, 21–4, 26–9, 30–45, 48–9, 52, 75; fig.19
 Belmont 15, 35, 37; fig.4
 church 7, 40, 57; fig.1
 Church-House project 68
 Fernlea 15, 16, 19, 22, 23, 24, 26, 27–8, 34, 35, 37, 38–9; fig.4
 map fig.20
 The Nest 16, 35

Dix, Otto 10
Donne, John 20, 22, 40; fig.9
Dyce, William
 Gethsemane 33; fig.21

First World War 11, 32, 45, 50, 61–7
Freud, Lucian 51
Frith, William Powell 75
Fry, Roger 17, 18

Gauguin, Paul 9, 17, 20, 33
Gertler, Mark 18
Giorgione 61
Giotto di Bondone 18, 62, 63
 Joachim Among the Shepherds 35, 62;
 fig.23
Gogh, Vincent Van 17
Gozzoli 61

Heidegger, Martin 10
Hepworth, Dorothy 48, 52, 54–5;
 fig.40
Hunt, William Holman 33

Italian Renaissance 10, 18, 20, 24, 26,
 34–5, 61

Kajuraho temple 68
knighthood 9

Lamb, Henry 24, 26, 62, 64
landscapes 9, 11, 21–2, 28, 38, 52, 55,
 61
Le Fanu, Brinsley 17, 18
Lewis, Wyndham 20, 74–5
Lithgow shipyard, Port Glasgow 69;
 fig.52

MacCarthy, Fiona 35, 55
MacDonald, Malcolm 57
Macedonia 61, 62, 63, 64
Marsh, Edward 24, 69
Masaccio
 Peter Healing the Sick with his
 Shadow 35; fig.22
Matisse, Henri 20
Mercer, Vaudrey 73
Merleau-Ponty, Maurice 74
Millais, John Everett 18, 33–4
Modernism 9–10, 11, 18, 20, 22
Munday, Elsie 47, 68, 72; figs.33, 54
Munnings, Sir Alfred 57
Murray, Charlotte 58, 68
music 15, 73

Nash, Paul 18
Neo-Primitives 35
Neue Sachlichkeit 10
Nevinson, C.R.W. 18

obscenity, threatened prosecution for
 57
Old Master paintings 24, 26, 61

patrons 17, 24, 27, 62
Picasso, Pablo 17, 20
Piero della Francesca 20
portraiture 9, 61
Post-Impressionism 17, 18, 20, 22
Preece, Patricia 48–51, 68, 72
 marriage to Spencer 7, 27, 37,
 49–55, 57; fig.40
 portraits by Spencer 37, 49, 51–2,
 57; figs.25, 37, 38, 41

Pre-Raphaelite Brotherhood 11, 18,
 20, 33–4

Rackham, Arthur 17, 18, 20
Raphael 61
Raverat, Gwen 24, 62
Raverat, Jacques 62
Rivera, Diego 10
Rossetti, Dante Gabriel 34
Rothenstein, Elizabeth 29, 57
Rothenstein, John 57
Royal Academy, Spencer's membership
 9
Ruskin, John 62

Sandham Memorial Chapel 9, 46–7,
 61–7, 72; figs.46–50
Second World War 69
Slade School of Fine Art 9, 17–20, 22,
 24, 32, 35
Slade Sketch Club 19
Spencer family 15–16, 27–8, 37, 42,
 66; fig.5
Spencer, Gilbert (brother) 15, 16, 17,
 20, 28–9, 37, 38–40; fig.5
Spencer, Shirin (daughter) 46, 61
Spencer, Stanley, works: Adoration of
 Girls 68; Adoration of Old Men 68;
 Age 55, 57; The Apotheosis of Hilda
 57, 75; Apple Gatherers 13, 20, 22,
 33; fig.3; At the Chest of Drawers 28;
 fig.16; The Baptism of Christ 68;
 Beatitudes of Love 55, 57, 69, 71;
 fig.41; The Betrayal 24, 33, 38;
 fig.26; Bridesmaids at Cana 27, 69;
 fig.15; The Centurion's Servant 24,
 39; Christ Carrying the Cross 33,
 35–7, 42, 66, 74; fig.24; Christ in
 Cookham 45; fig.31; Christ Preaching
 at Cookham Regatta 74, 75; fig.56,
 frontispiece; Christ's Entry into
 Jerusalem 33; fig.42; Christ in the Wilderness
 series 57; fig.42; Consciousness 55;
 Contemplation 55; Cookham from
 Cookham Dene 30; fig.18; Cookham
 Moor 28; fig.17; Desire (Passion) 55,
 57; fig.41; Domestic Scenes 28, 59,
 69; figs.16, 43; Double Nude Portrait,
 The Artist and his Second Wife (Leg of
 Mutton Nude) 7, 51–2; The Dustman
 (The Lovers) 42–3, 69; fig.28; The
 Fairy on a Waterlily Leaf 18–19; fig.6;
 Gardens in the Pound, Cookham 52;
 fig.39; Glasgow Resurrection series
 69, 75; Hilda and I at Burghclere 60;
 Hilda Drying Herself 73; fig.55; Hilda
 Welcomed 60; Jacob and Esau 18, 19;
 Joachim Among the Shepherds 24, 33,
 62; fig.12; John Donne Arriving in
 Heaven 20, 22; fig.9; Knowing 55;
 'Last Day' series 40, 42–5, 60, 69,
 71; The Last Supper 33; Love Among
 the Nations 50, 68; fig.35; Love
 Letters 12; fig.2; Love on the Moor
 43–4, 51, 52, 60; fig.30; The
 Marriage at Cana 16, 68, 69; fig.53;
 Me and Hilda fig.44; The Meeting 37,
 49; fig.25; Mending Cowls, Cookham
 23, 24, 74; fig.11; The Nativity 16,

20, 29, 33, 37; fig.10; Nearness 55;
 Nude (Portrait of Patricia Preece) 52;
 fig.38; The Nursery 27; Patient
 Suffering from Frostbite 66; fig.49;
 The Pentecost 68; Portrait of Hilda
 48; fig.34; The Resurrection, Cookham
 (1924–7) 7, 9, 11, 40–2, 46, 62, 66;
 figs.1, 32; The Resurrection of the
 Good and the Bad 40; The
 Resurrection of the Soldiers 63–4, 66;
 fig.48; Reveille 66; fig.50; St Francis
 and the Birds 7, 27; fig.14; Sarah
 Tubb and the Heavenly Visitors 42,
 68; fig.27; Scene in Paradise 19–20,
 27; fig.8; The Scorpion 57; fig.42;
 Scrapbook drawings 59–60, 72–3;
 figs.54, 55; Seeing 55; Self-Portrait
 (1914) 24; Self-Portrait with Patricia
 Preece 51–2; fig.37; Shipbuilding on
 the Clyde: Furnaces 69; fig.52;
 Sunflower and Dog Worship 7, 51;
 fig.36; Taking off Collar 59; fig.43;
 Taking in Washing, Elsie 72–3; fig.54;
 Travoys with Wounded Soldiers
 Arriving at a Dressing Station at Smol,
 Macedonia 61; fig.45; Two Girls and a
 Beehive 19, 37; fig.7; A Village in
 Heaven 43, 50–1, 68; fig.29; Villagers
 and Saints 42, 68; Worship 55;
 Zacharias and Elizabeth 16, 24, 28,
 33, 37; fig.13
Spencer, Unity (daughter) 47

Tonks, Henry 19, 20
Tooth, Dudley 52, 57
Tweseldown Camp, Aldershot 63

Vlaminck, Maurice de 20

Wadsworth, Edward 18
Wood, Jas 23; fig.40
Wooster, Dorothy 19
written works 11–14